UNDER THE DARK SKY

UNDER THE DARK SKY
Life in the Thames River Basin
of Eastern Connecticut & South Central Massachusetts

A PHOTO ESSAY BY **STEVEN G. SMITH**
FOREWORD BY **STEVE GRANT**

Wesleyan University Press
Middletown, Connecticut

Published by Wesleyan University Press, Middletown, CT 06459
www.wesleyan.edu/wespress
Copyright © 2018 by Steven G. Smith
Foreword Copyright © 2018 by Steve Grant
All rights reserved

Published in 2018. First edition.
Designed by Steven G. Smith
Printed in China

Library of Congress Cataloging-in-Publication Data available upon request
Hardcover ISBN: 978-0-8195-7840-2
Ebook ISBN: 978-0-8195-7841-9

ON THE COVER: The glow of sunrise contrasts against the dark night sky on Bigelow Pond in the northern reaches of the Thames River Basin near Union, Connecticut. This part of the valley is considered to be the last stretch of dark night sky viewed by the massive population between Washington, D.C. and the Boston metro area. Bigelow Pond is a 24-acre lake in Bigelow Hollow State Park, which, along with adjoining the Nipmuck State Forest, offers 9,000 acres of forested woodlands.

To all the lovers of New England and to the people who appreciate quiet, understated beauty

To my wife, Gwyn, and my two boys, Luke and Cole, thank you for your willingness to journey with me

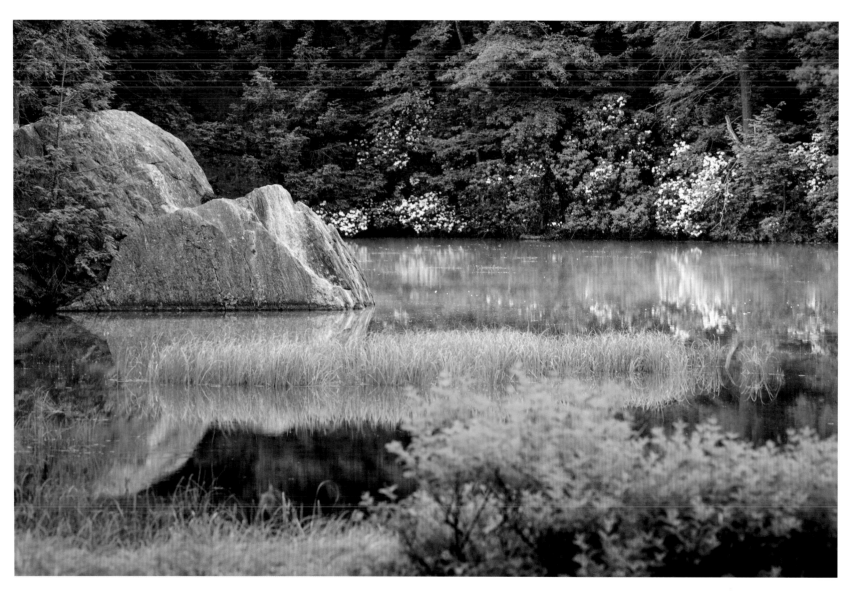

Granite boulders mark the edge of Bush Meadow Brook in the northern corner of Connecticut. In 1994, the U.S. Congress designated a 35-town area in eastern Connecticut and south-central Massachusetts as a National Heritage Corridor. It was recognized because it is one of the last remaining stretches of green in the region and boasts some of the largest unbroken forests in southern New England.

"Green by day" and "dark at night," this corridor is a relatively undeveloped notch in the midst of the most urbanized region in the nation. By day, green fields and forests confirm the surprisingly rural character of our towns. At night, the region appears distinctively dark amid the urban and suburban glow when viewed from satellites or aircraft.

— *LyAnn Graff, The Last Green Valley National Heritage Corridor*

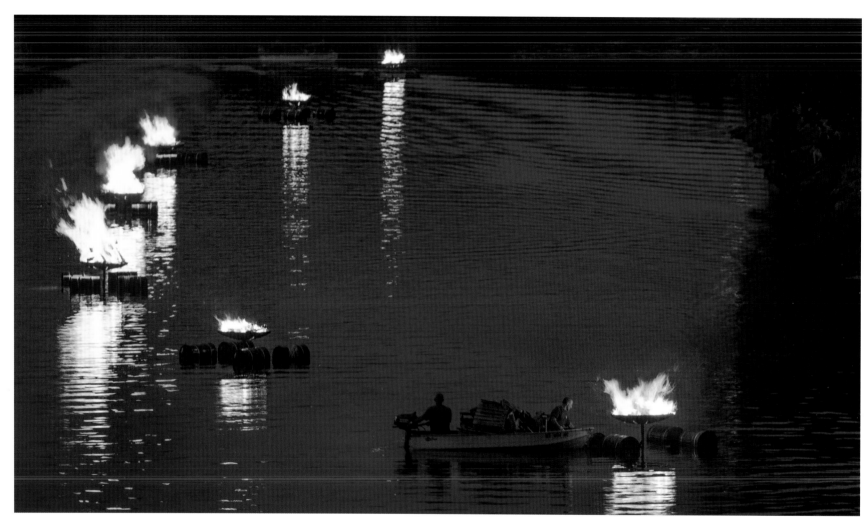

The summer celebrations held by the city of Putnam, Connecticut, include the Riverfire event on the Quinebaug River. Bonfires are lit on flotillas while the town folk sit on the banks and enjoy music and an evening out. The Thames River has 17 tributaries, including the Quinebaug River, which flows for 69 miles.

Contents

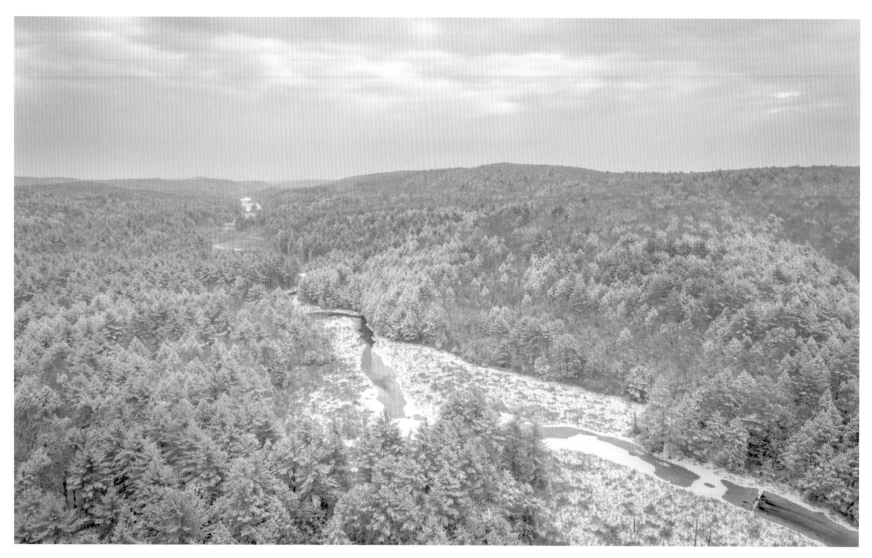

Bigelow Brook meanders through the Yale-Myers Forest near Union, Connecticut. Yale University owns nearly 8,000 acres in the northern reaches of the Thames Watershed just south of the Massachusetts border. The forest is reported to be the largest private holding in the state and is managed by the Yale School of Forestry & Environmental Studies. Yale offers graduate level studies in forestry and is the oldest graduate program in the country. The brook makes its way from Mashapaug Lake in Union all the way to the Still River, forming the Natchaug River in Eastford, Connecticut.

Foreword

Look closely at a map of eastern Connecticut; brooks, streams, rivers, everywhere. Drive the roads; small farms, small towns, small cities. Adjoining them are public and private forests spread over tens of thousands of acres. In the fields, and even in the woods, are centuries old stone walls, relics from the eighteenth and early nineteenth centuries when all of eastern Connecticut was patchworked farmland. Along many of the waterways are old textile mills, some empty and windowless, some morphing handsomely into twenty-first century usefulness as condos, restaurants and shops. Along the coastline, or near it, are colleges, gambling casinos and heavy industry.

This is the Thames River watershed, a fluvial web of waterways from which the aesthetic and cultural soul of modern-day eastern Connecticut evolved.

Steven G. Smith, associate professor of visual journalism at the University of Connecticut in Storrs—the university itself is an enormous presence in the valley—has masterfully captured the essence of the Thames watershed in the pages that follow. The rivers, the forests, most of all the people, are here, the overall effect of his images providing a real sense of life in the region.

"In many ways, Eastern Connecticut is still the state at its truest; a place where the character, culture and natural beauty of this state remains largely untransformed by proximity to New York and Boston," says Walter W. Woodward, associate professor of history at the University of Connecticut, the designated state historian, and a resident of the Thames River valley himself.

In *Connecticut: A Guide to its Roads, Lore and People*, a 1938 book produced by the Federal Writers' Project of the Depression-era Works Progress Administration, eastern Connecticut is described as mostly rural, with a long, rich history. It was, for example, along a trail that passed through northeastern Connecticut—which became known as the Connecticut Path—that the state's first European settlers arrived in the early seventeenth century. It was on the many streams of the Thames watershed that the Industrial Revolution flourished in the nineteenth and early twentieth centuries.

"Streams are pure, swift, and boisterous," the Writers' Project authors wrote. Crossroads hamlets "cling to the edge of scattered farmlands." More than 75 years later, nearly the same can be said. Wild, native brook trout, extirpated from much of the Northeast, still flourish in many of the brooks and streams in the northern reaches of this watershed. Hamlets like Phoenixville still exist.

Some of the wildest country in Connecticut is in the northeast, near the borders with Massachusetts and Rhode Island, where the landscape is dominated by large blocks of forest. Airline pilots flying the eastern seaboard at night know the area as the dark corner, a distinct expanse of black in the otherwise well-lit Washington to Boston corridor.

Perhaps the Thames River watershed can best be understood compared to a letter Y, the left fork being the Shetucket River and its tributaries, the right fork the Quinebaug River and its tributaries. Where they meet, at Norwich, they become the Thames, which flows to the sea.

Much of eastern Connecticut, however changing, however modern, is at the same time a window into the past, perhaps the last remaining expression of colonial Connecticut culture, Yankee culture, as it evolved over the centuries. "It's where Connecticut's revolutionary spirit first came to life and where the New Light of the Great Awakening shined brightest," Woodward says. "Drive through its hills and valleys, paddle its rivers, or walk its trails—most of all, talk to the people of eastern Connecticut and you'll understand what's Connecticut about the Connecticut Yankee." In places like Woodstock, change comes slowly, and the colonial and agrarian past is respected. Woodstock consists of nicely kept old homes and a town green, and produces a country feel, with woods never far away.

Eastern Connecticut might even qualify as a microcosm of New England history, shaped by the enormously powerful influences of early Puritan life, the American Revolution, waves of immigration, and world wars.

Today it is shaped by twenty-first century trends. Small farms, which declined precipitously in the nineteenth century, pop up again as people in recent years increasingly value local produce. Forests, which were cleared for farming in the eighteenth and early nineteenth centuries, have rebounded so nicely since 1850 that in places they suggest the old growth forests that the first settlers encountered.

In the same watershed as Woodstock reside small towns like Griswold and Bozrah, far less affluent, but the kind of towns where a family tends a vegetable garden, where a pickup truck is often the vehicle of choice. Old mill towns, like Danielson, Willimantic and Putnam, are in some ways still struggling with the loss of the textile industry, yet virtually all of them are reinventing themselves after years of decay. In the Taftville section of Norwich, on the banks of the Shetucket, the nineteenth-century Ponemah Mills complex, for example, once the world's second largest textile mill, is now a massive housing complex.

In the lower reaches of the watershed, from Norwich south, population density is higher, the roads are busier, and the Thames is now a tidal presence so vast it carries submarine traffic. Here, the watershed that begins in woods, part of it just above the Connecticut border in Massachusetts, blends into the eastern megalopolis.

Native people of this region have survived through centuries of colonization. Their ancestors were here in the Thames valley when the first European settlers arrived in the seventeenth century. Today, the Mashantucket Pequots operate the Foxwoods Resort Casino on their land in Mashantucket. The Mohegan Tribe, which has its reservation on the Thames in Uncasville, operates the Mohegan Sun casino on its land. The casinos are a significant economic driver in the state, and also support a world-class museum and education center for the study of Native history and culture.

Important state and national institutions are based near the Thames. The U.S. Coast Guard Academy and Connecticut College are highly regarded educational institutions near the mouth of the river. Pfizer, a global pharmaceutical company, has its research labs in Groton, where the Thames meets the sea. The General Dynamics Electric Boat Division, also in Groton, builds nuclear submarines for the U. S. Navy.

Smith spent three years traveling the watershed, photographing forests, streams, farms, homes, cultural events, and commercial and industrial institutions. Enjoy the photos on the following pages, for they amount to a distillation of the landscape and culture of a region that may well be the last remaining expression of an idyllic nineteenth century Connecticut.

— *Steve Grant, 2017*

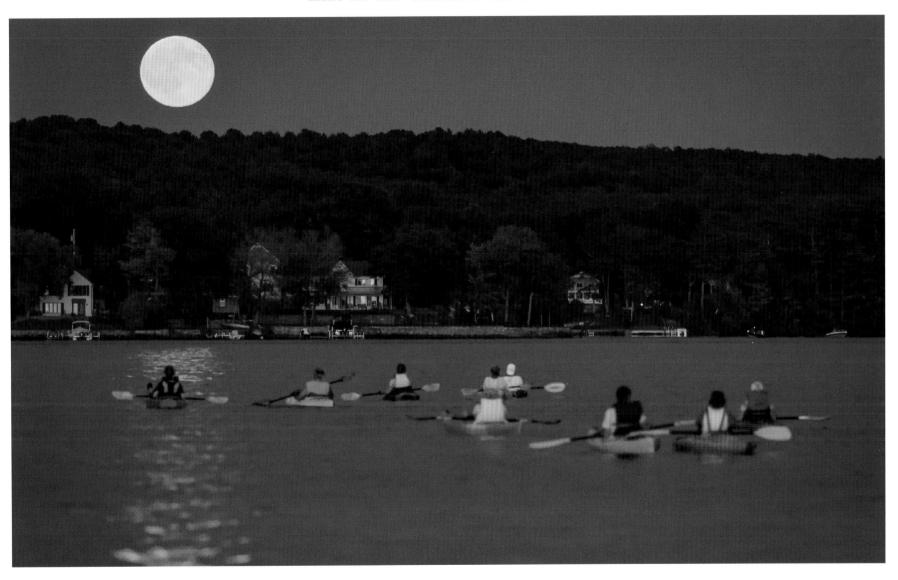

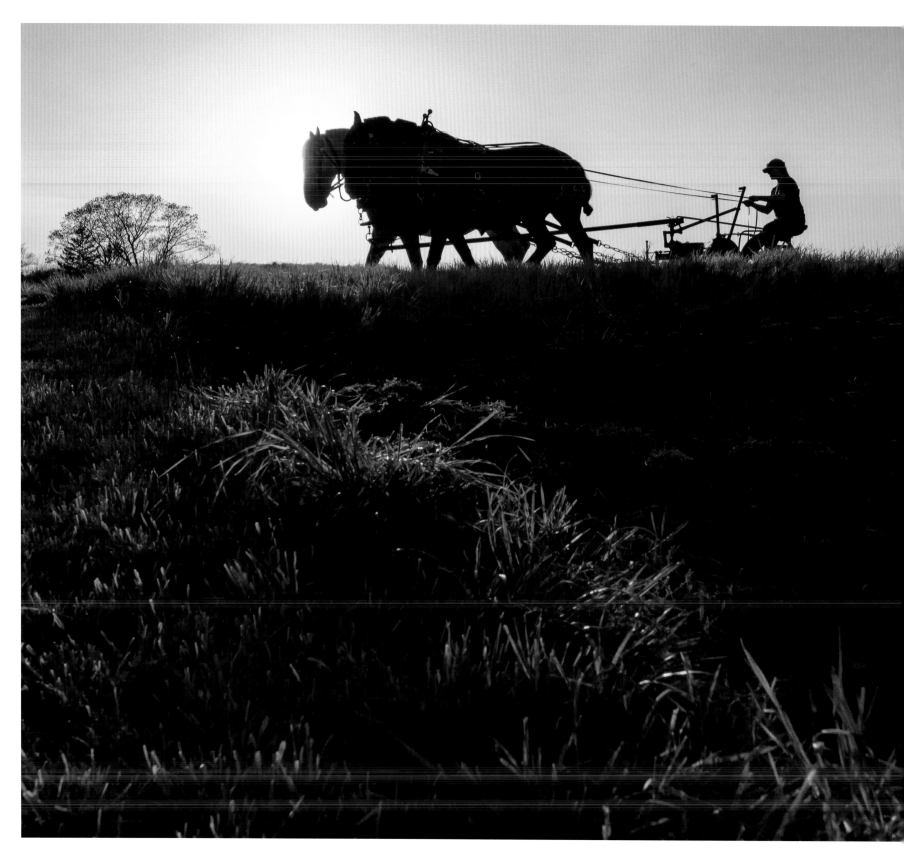

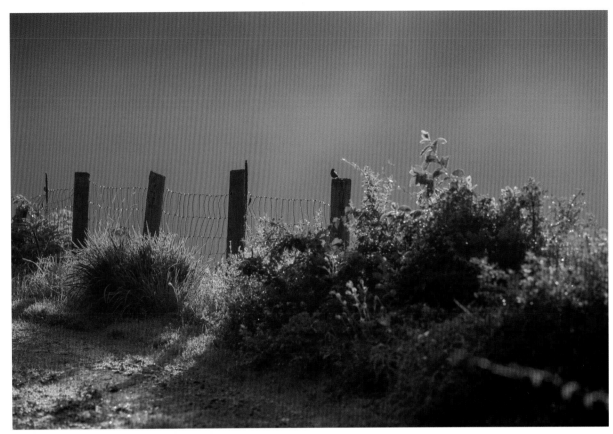

Above: The early morning sun tries to penetrate a thick fog rising near Mansfield, Connecticut. At one time, Mansfield was considered to be the center of American silk culture. Many of the farms in the area had mulberry orchards to feed silkworms. The first water-powered silk mill was built in the area, and now resides in the Henry Ford Museum.

Left: Erika Marczak works with her team of Percheron draft horses on her farm in Abington, Connecticut. Marczak has been farming for six seasons using low-impact farming techniques. Marczak and her partner, Sam Rich, operate Abington Grown, a small-market garden farm. Abington Grown is a no-spray, animal-powered produce farm. Percheron draft horses can weigh up to 2,500 pounds and were historically popular for pulling large agricultural loads.

Previous page: Kayakers take in the view of the moonrise on Webster Lake in Webster, Massachusetts. The lake is famous for its Native American name Lake Chargoggagoggmanchauggagoggchaubunagungamaugg - one of the longest lake names in the United States. The headwaters of the Thames River Basin extend nearly twenty miles into Massachusetts.

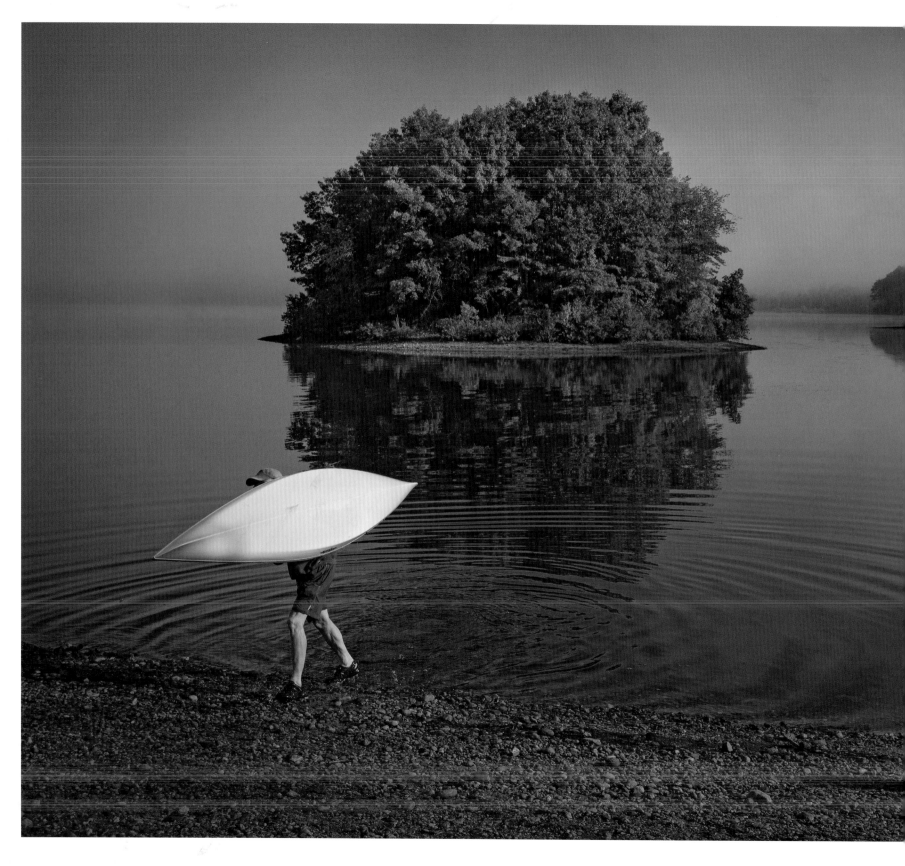

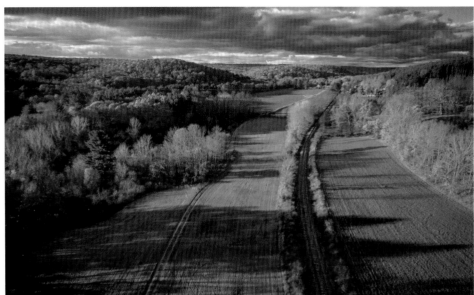

Above: The University of Connecticut operates several active farms in the valley. The Spring Valley Student Farm is located five miles from the Storrs campus. Students live on the farm and study sustainable farming practices. Food from the farm is served in the university's dining halls.

Left: Phil Levin carries his kayak back to his vehicle after a morning out on Mansfield Hollow Lake in Mansfield, Connecticut. In 1952 the United States Army Corps of Engineers completed the dam on Mansfield Hollow Lake. The reservoir was created to prevent future flooding in the area. Additional dams were also built on a number of the tributaries after major flooding had devastated parts of the region in 1936, 1938 and 1955.

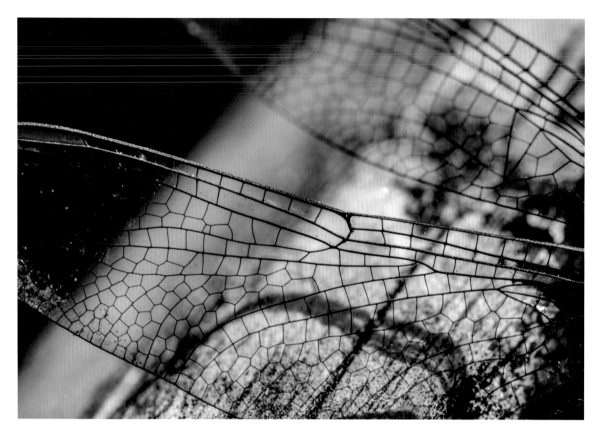

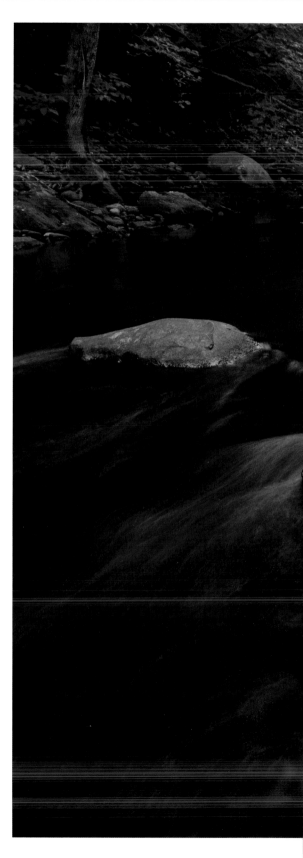

Above: A dragonfly waits for the early morning sun to warm his wings along the shore of the Pachaug River in Eastern Connecticut. The river runs through Pachaug State Forest, which is the largest state forest in Connecticut, covering 24,000 acres and five towns.

Right: The Willimantic River flows for twenty-five miles between Stafford Springs and Willimantic, Connecticut. In the early 1900s, this area was the location of a gunpowder mill. The now-healthy river was void of fish for thirty years due to pollution. The river supported water-powered textile mills and other types of mills in Stafford Springs, South Willington, Merrow, Eagleville, and Willimantic.

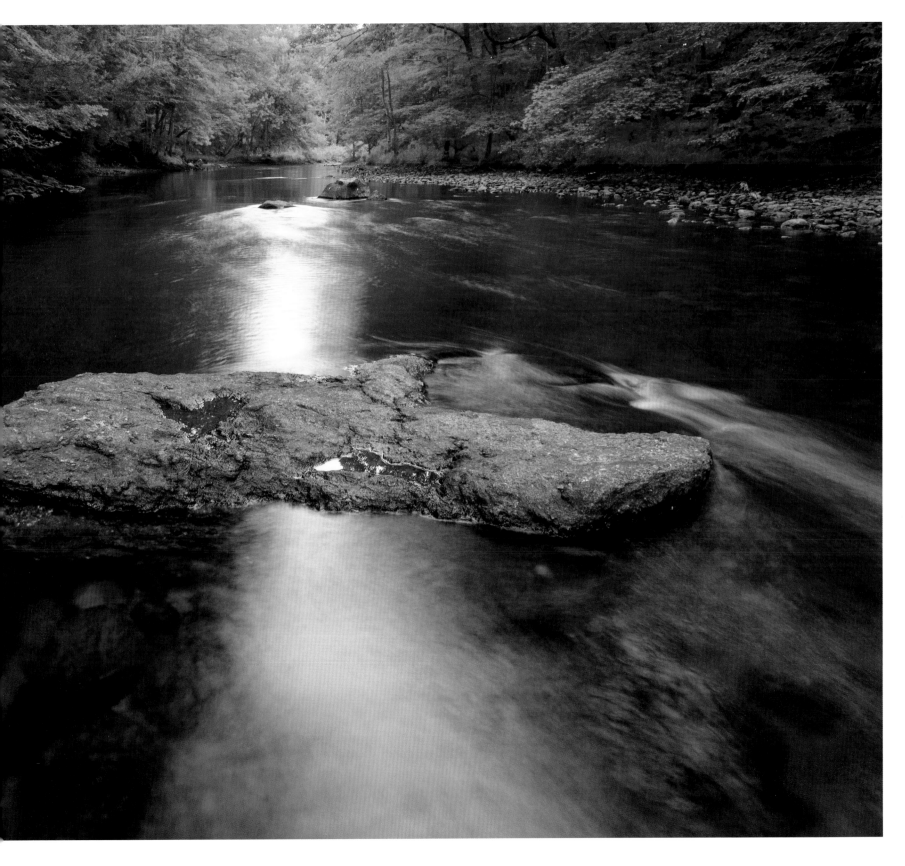

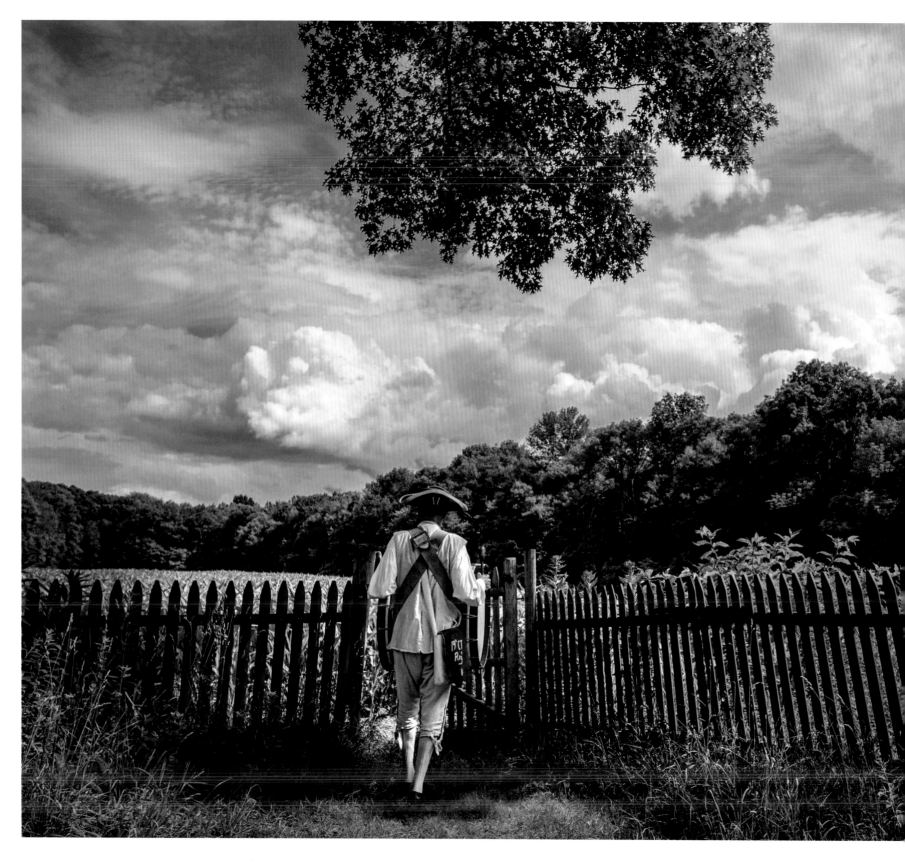

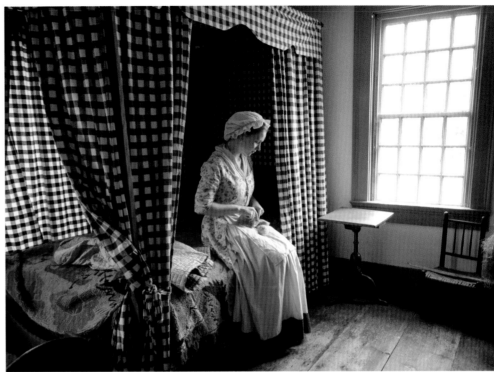

Above: Laura Walls, a museum docent, pauses from her tour of duties at the Nathan Hale Homestead in Coventry, Connecticut. Nathan Hale Homestead is the family farm of Connecticut's state hero, Nathan Hale, who was hanged as a spy during the Revolutionary War. Hale is famous for his last words, "I only regret that I have but one life to lose for my country."

Left: Curt Patch of the Nathan Hale Ancient Fifes and Drums walks into a cornfield on the Nathan Hale Homestead after a celebration remembering the Hale family. After graduating from Yale in 1773, Nathan Hale became a teacher at East Haddam. A statue in memory of Nathan Hale stands in a courtyard of the Old Campus at Yale University in New Haven, Connecticut.

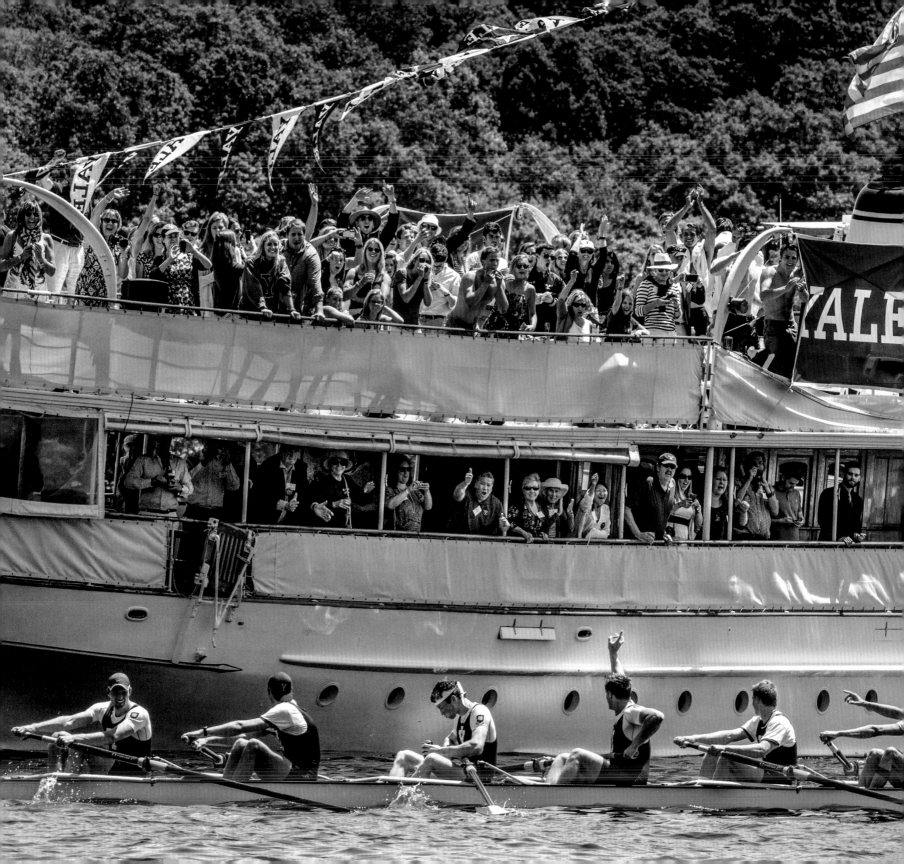

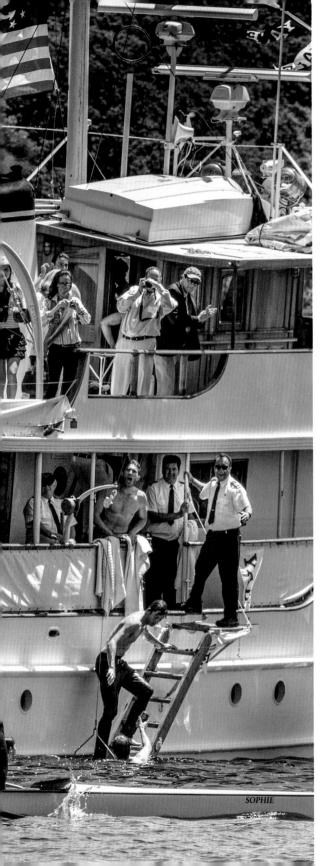

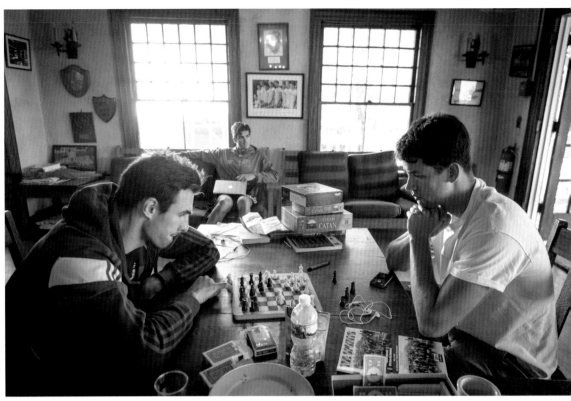

Above: The Harvard-Yale Regatta is America's oldest collegiate athletic competition. Members of the Yale crew team Hubert Trzybinski (left) and Nate Goodman play chess during their downtime at Yale's Gales Ferry quarters in Connecticut.

Left: Members of the Yale Men's Heavyweight Crew Team celebrated as they passed a yacht full of Yale fans on the Thames River near Gales Ferry, Connecticut. The Harvard-Yale Regatta was first contested in 1852.

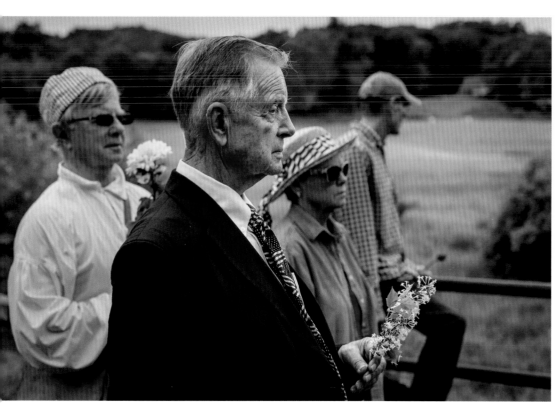

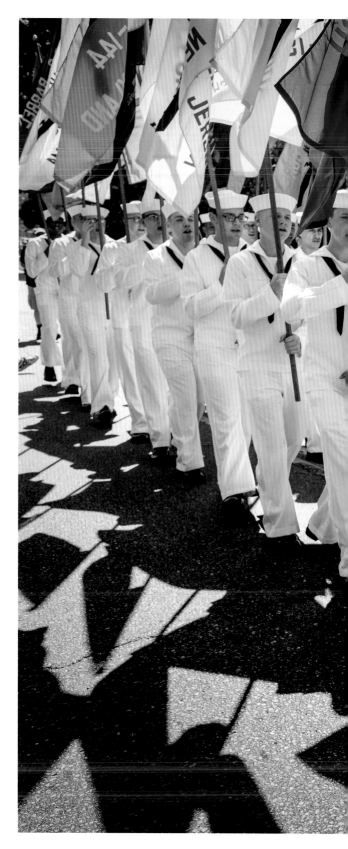

Above: Morris Burr, 87, stands on the town bridge over the Little River in Hampton, Connecticut. The group had collected wildflowers to cast into the stream as part of the Naval Memorial Day ceremony.

Right: Sailors from the Naval Submarine Base in New London, Connecticut, carry flags depicting submarines lost at sea at the Groton 4th of July Parade in Groton, Connecticut. The New London Naval base is considered the primary submarine base on the East Coast and is located several miles up the Thames River.

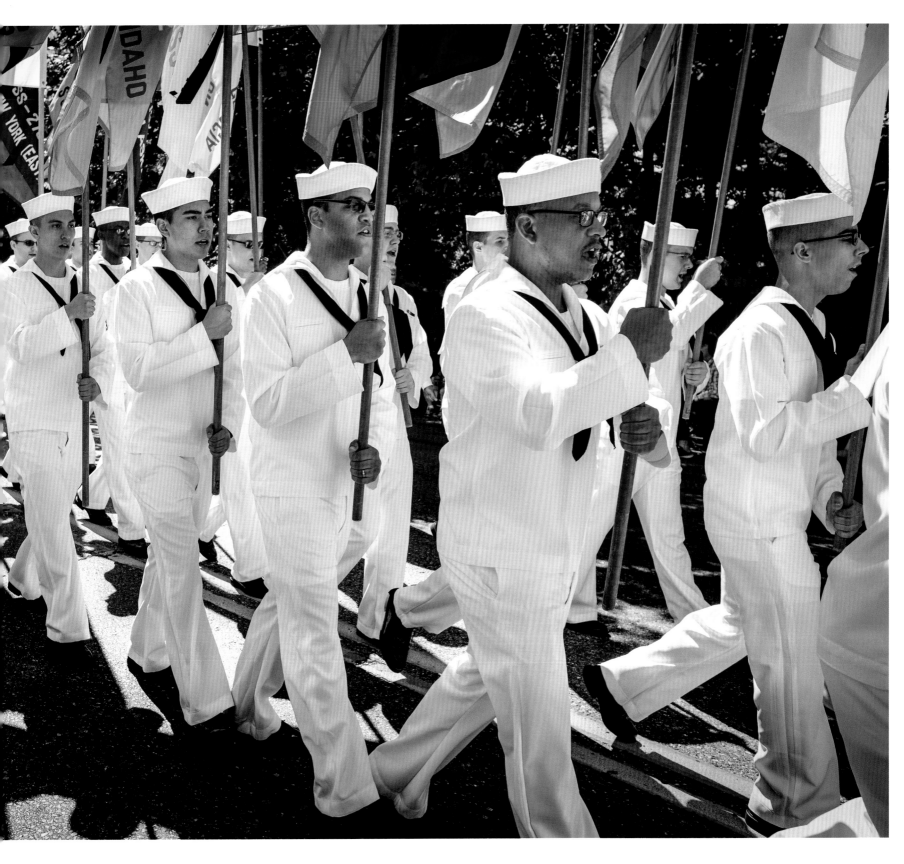

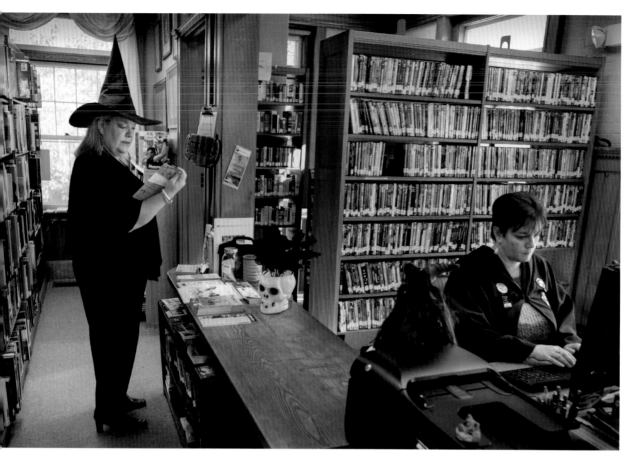

Above: Dressed for Halloween, Ellen Silbermann (left) and Library Assistant Donna Jellen are working at the Union Free Library. Union is the smallest town in Connecticut, with just 854 residents counted in the 2010 census.

Right: The Harvest Festival at Buell's Orchard brings people to the farm to pick apples and pumpkins. Henry Buell founded the farm in 1889. Four generations of the Buell family have worked this land in Eastford, Connecticut.

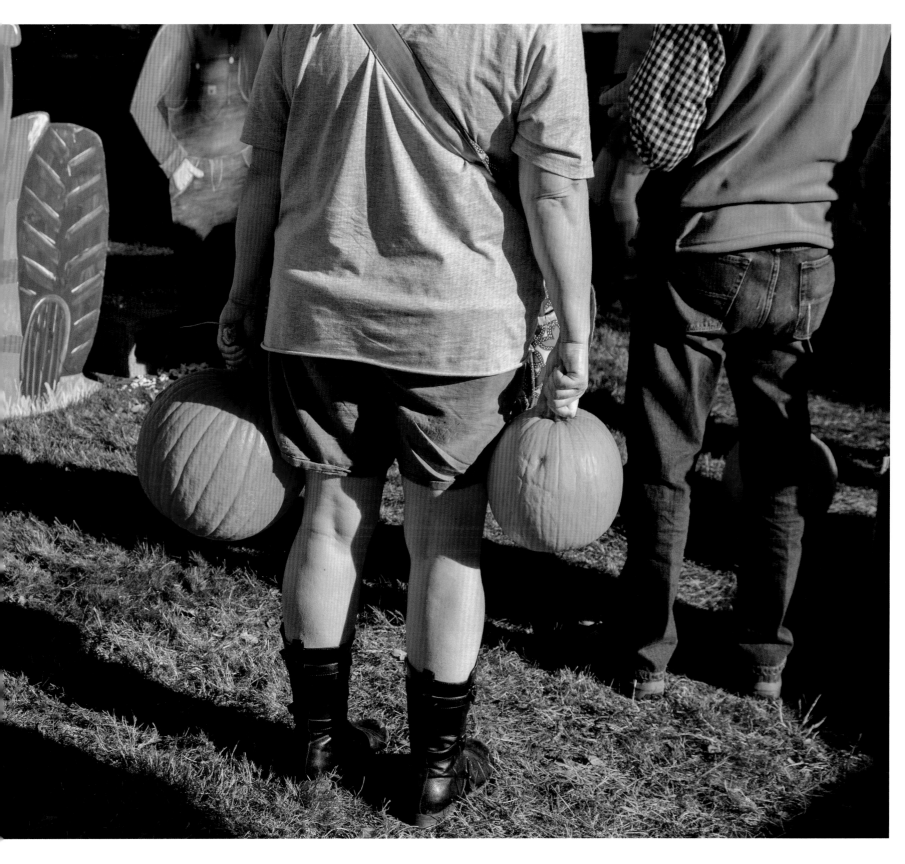

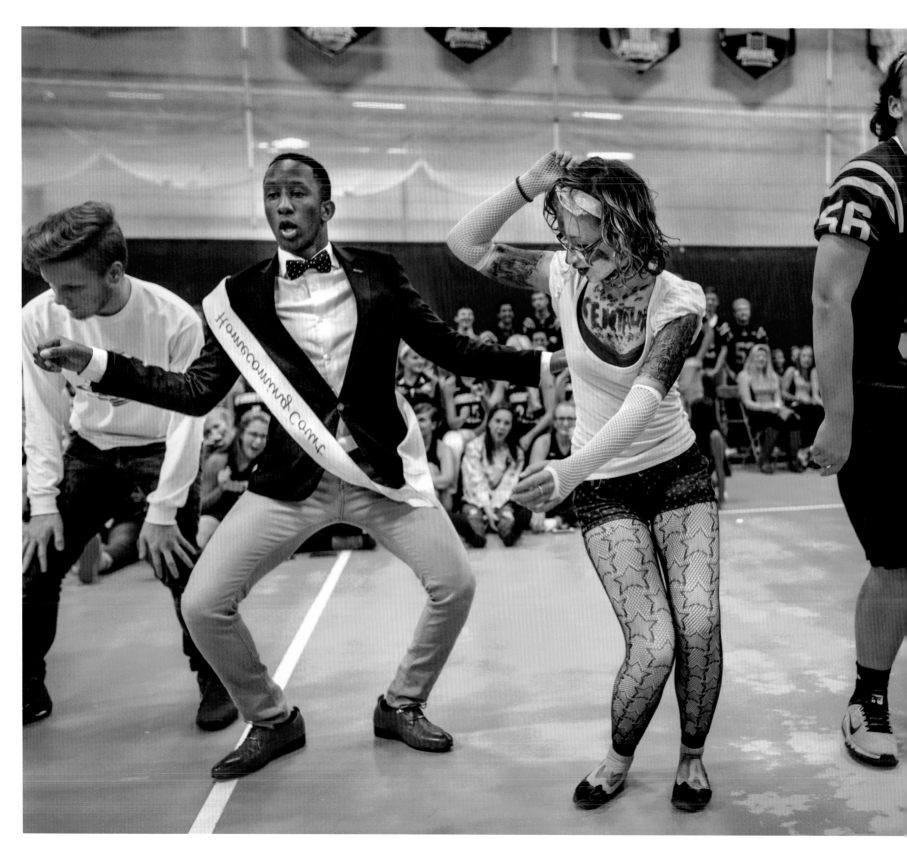

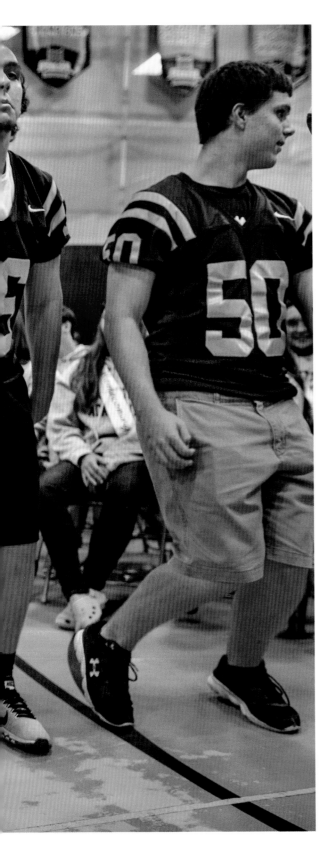

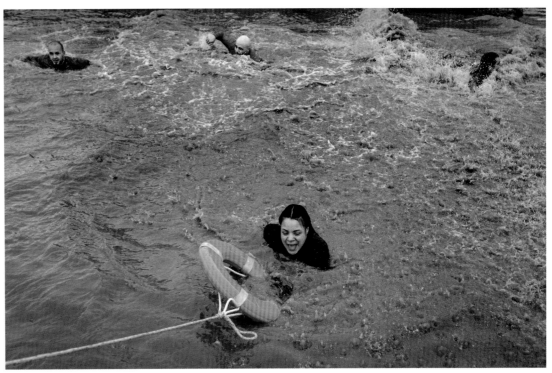

Above: Glenda Slaughter gets some help to shore at the Warrior Dash at the Thompson Speedway in Thompson, Connecticut. The Warrior Dash is a 5k obstacle race series. Slaughter tries to swim out of the chilly mudhole after sliding down the 30-foot slide. Thompson is in the northeast corner of the state, bordered on the east by Rhode Island and the north by Massachusetts. The Tri-State Marker is located to the east of Thompson.

Left: Woodstock Academy students dance during the Homecoming Pep Rally. Founded in 1801, Woodstock Academy is one of the oldest high schools in the country. The school is a unique combination of public and private. Tuition can be paid for by taxes or by students not from the area.

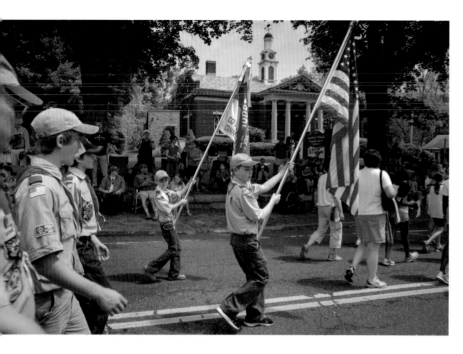

Above: Boy Scout group Troop 65 marches in the Memorial Day Parade in downtown Coventry, Connecticut. In 1711, Coventry was the first town in the colonies to be named after Coventry in the United Kingdom. The Booth & Dimock Memorial Library sits along Main Street in downtown Coventry. The library opened in 1913.

Right: In a tradition that dates back to its first graduation in 1919, Connecticut College junior class women carry a laurel chain in front of the graduating seniors. Connecticut College is a small private liberal arts college located in New London. The college was originally for women after Wesleyan University stopped accepting women in 1909. Connecticut College became co-ed in 1969.

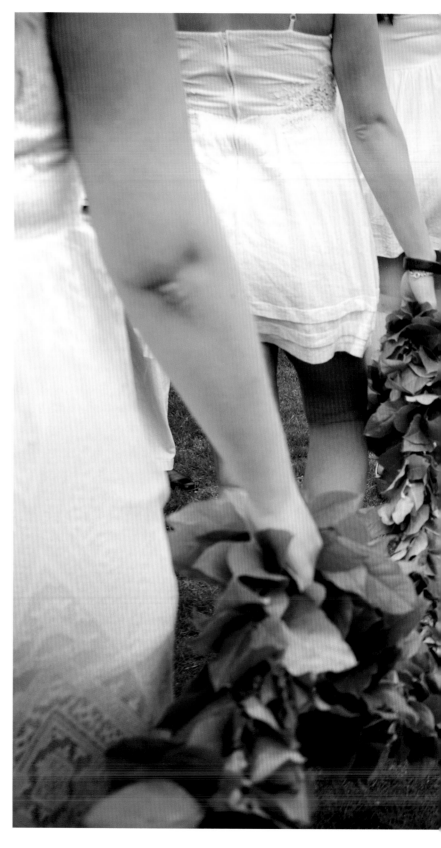

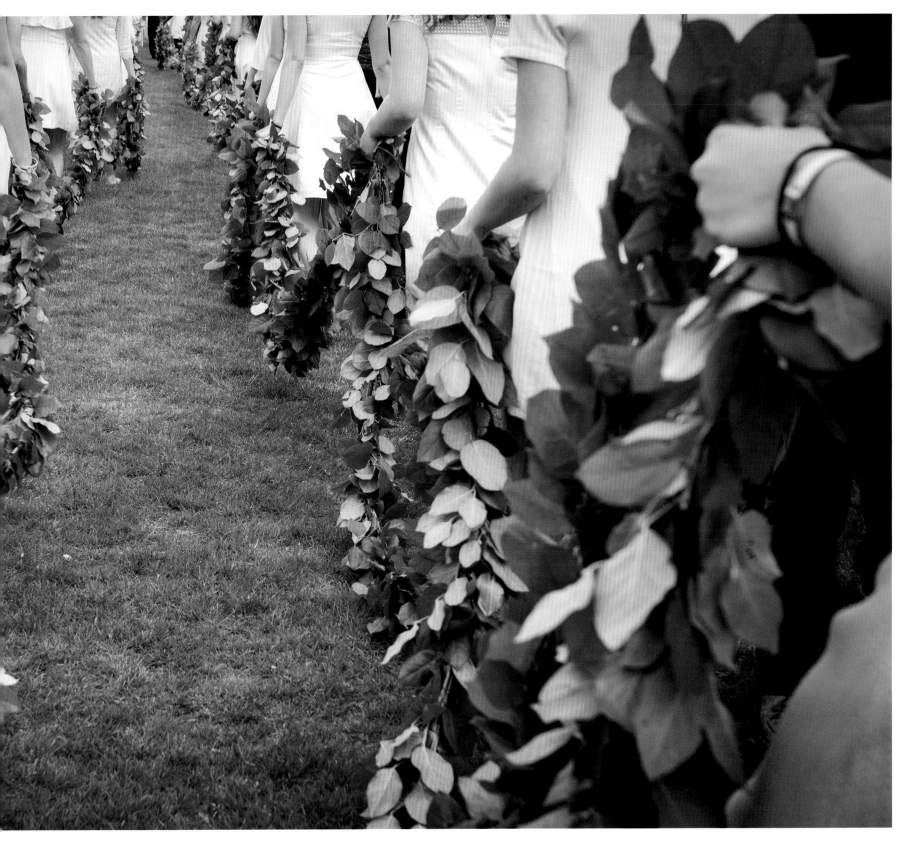

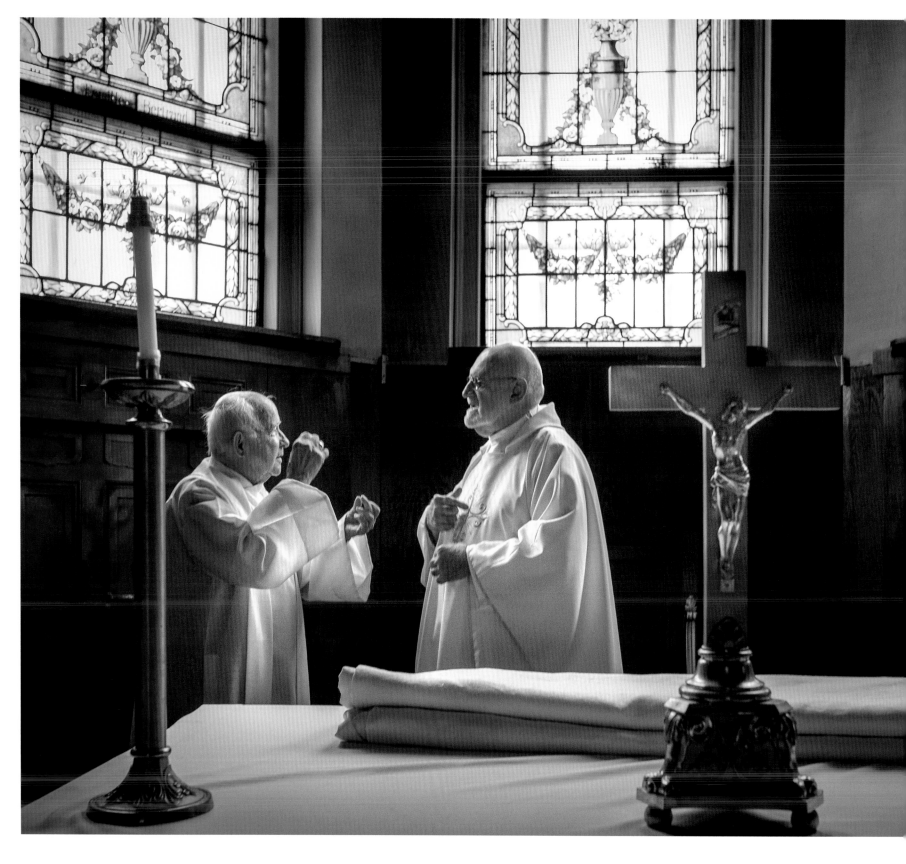

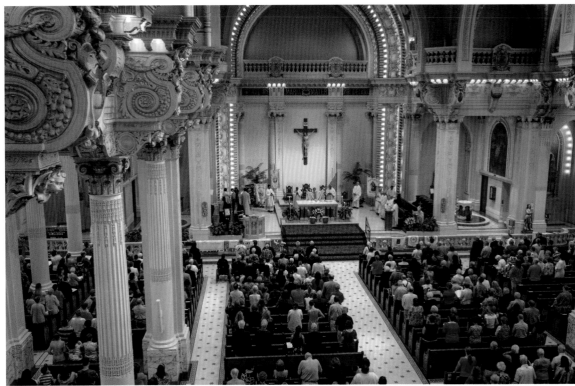

Above: Parishioners celebrate mass at the historic Notre Dame Catholic Church in Southbridge, Massachusetts. The church was finished in 1916. The ceiling is 55 feet high, and the building is 190 feet long. The building is listed on the National Register of Historic Places. The parish was founded in 1869 by French Canadian immigrants, many of whom had come to work in the local mills.

Right: Father George Charland (left) and Father David Galonek, both retired priests of the Diocese of Worcester, prepare to celebrate the 175th anniversary of the first Catholic mass in Southbridge, Massachusetts. Southbridge, is on the northernmost edge of the Thames River watershed.

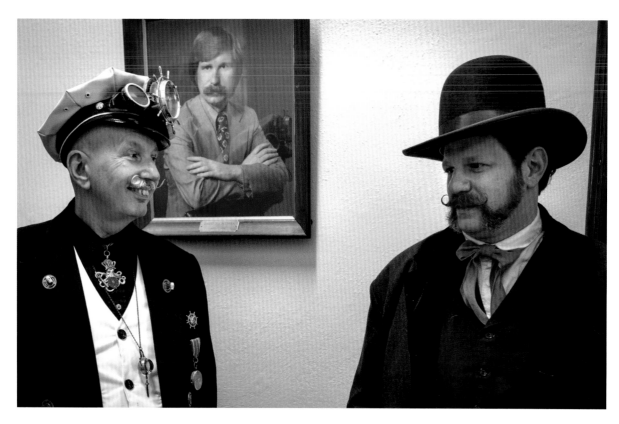

Above: Douglas Yeager (left) and Ron Black, dressed in Victorian attire, wait for the official tour of the old City Hall in Windham County, Connecticut. The historic town hall was built in 1896 and includes historical photos of previous mayors. The historic "Hill Section" of Willimantic has over 800 vintage structures and is listed on the National Register of Historic Places. In June of each year, the town celebrates its history with a Victorian Day celebration.

Right: Wesley Meseroll stokes the fire of an evaporator in maple syrup production at Owenco Farms Sugar Shack. The raw maple sap is processed by heating the material to evaporate the water, leaving only the syrup. Native Americans taught the early colonists how to extract the raw sap from maple trees.

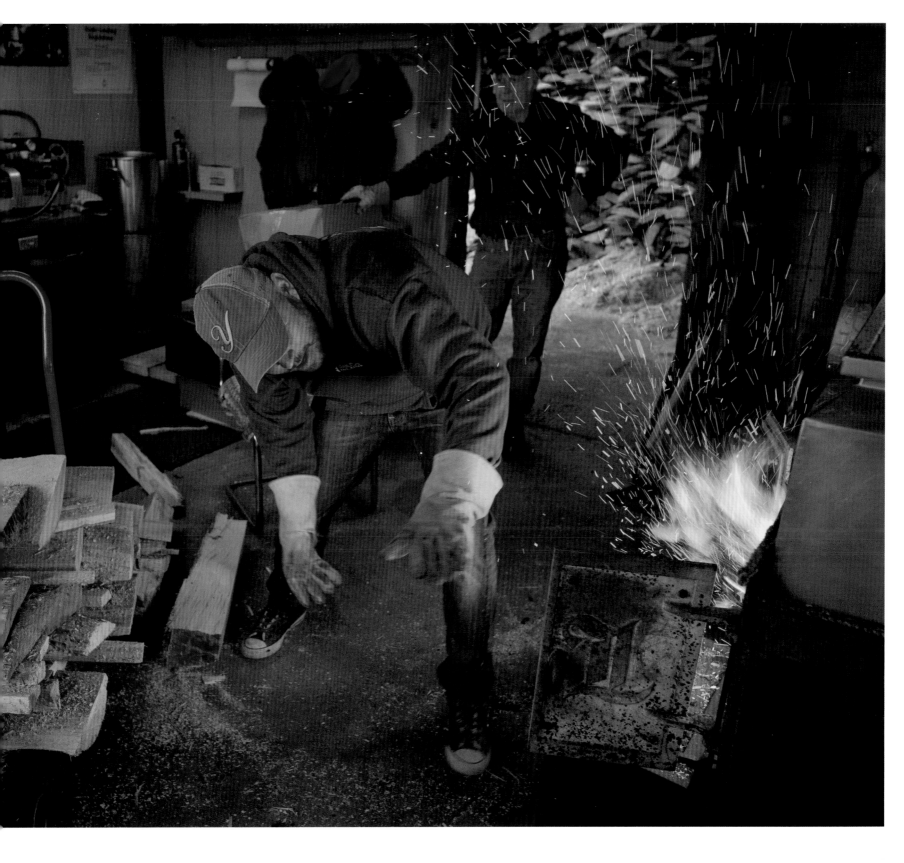

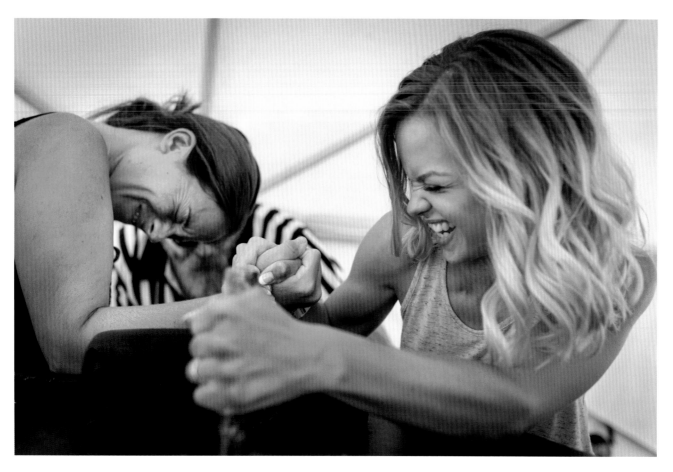

Above: Madison Michaud (right) of Groton, Connecticut, pins Katie Lisee (left) in the arm-wrestling competition at the Brooklyn Fair. The Brooklyn Fair claims to be the oldest continuously run fair in the country, having run since 1809.

Right: Beauty contestant Willow Rose Chesner waits to go on stage at the Miss Lebanon Fair Pageant at the Lebanon Country Fair. Lebanon, Connecticut, is located in New London County and was incorporated in 1700. The area still boasts over 100 active farms producing maple syrup, poultry, and cattle.

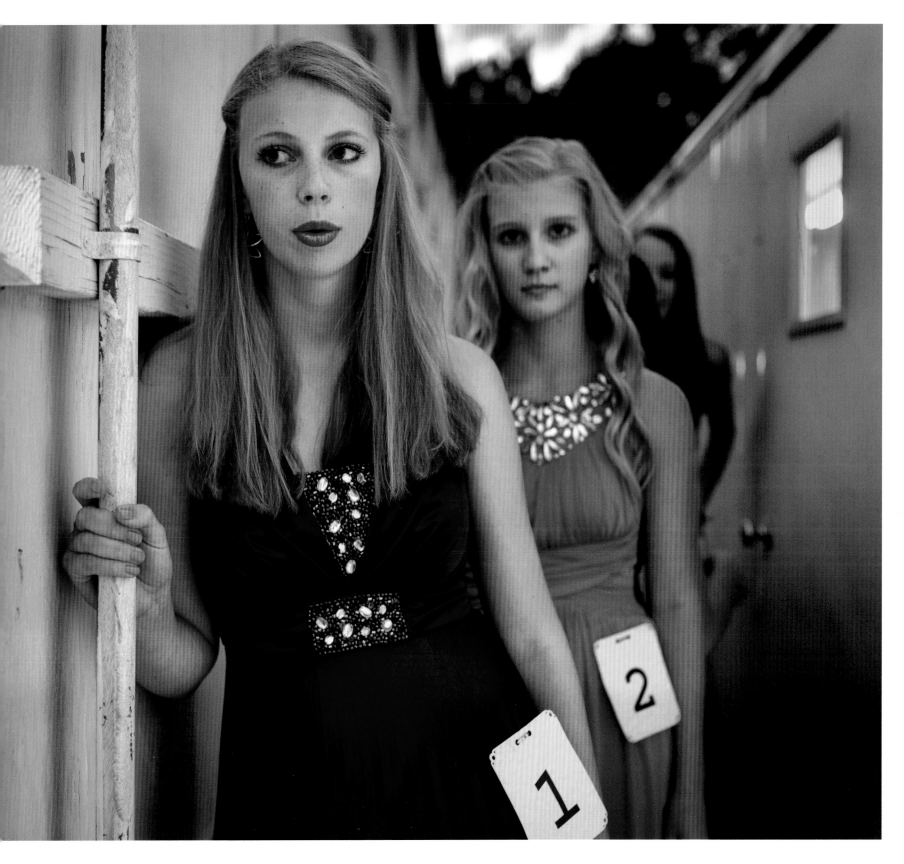

Autaquay Peters prepares to lay her blanket down after completing the Blanket Dance at the Mashantucket Pequot Museum pow-wow in Mashantucket, Connecticut. The museum celebrates the indigenous cultures and societies of North America. The Eastern Blanket Dance is a special courtship dance performed originally by women of the Northeastern Native tribes.

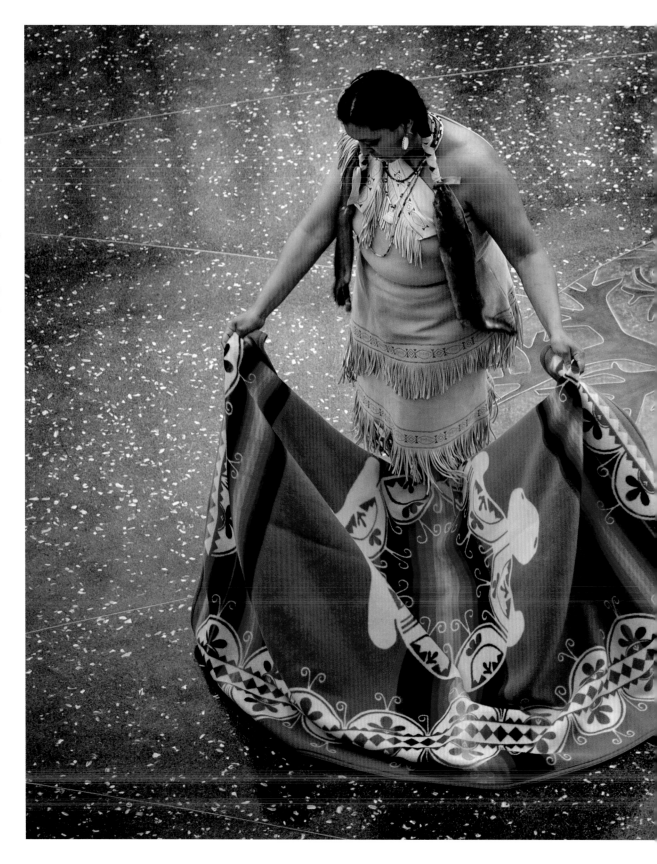

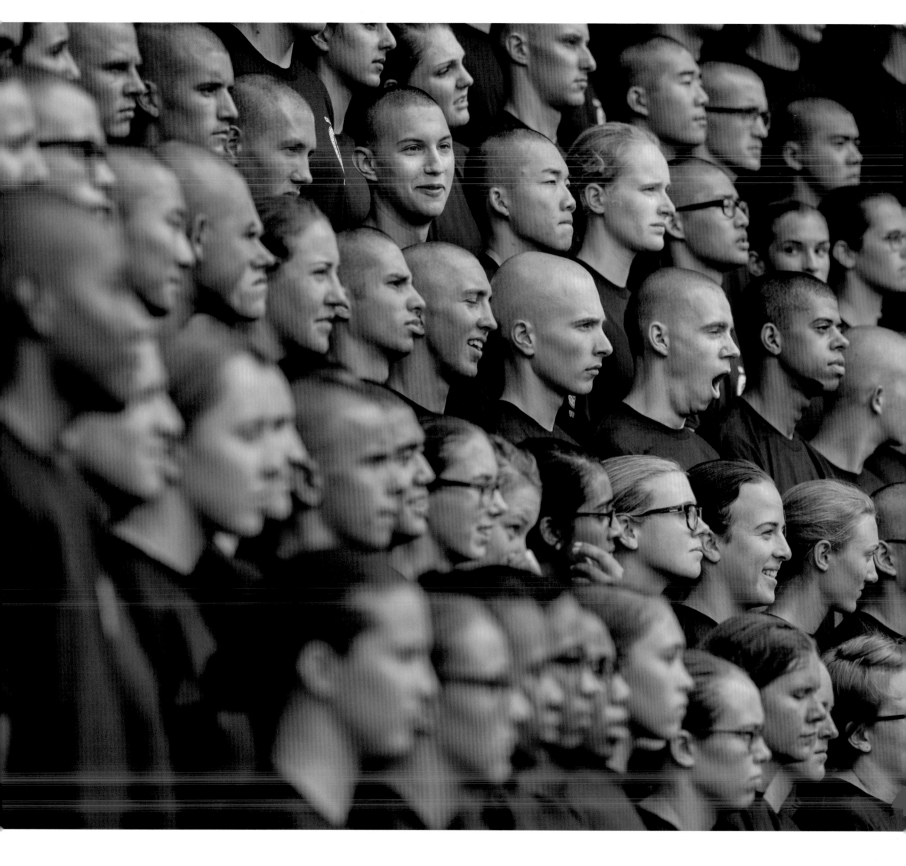

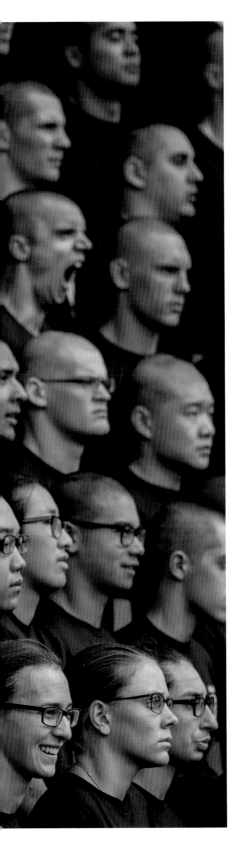

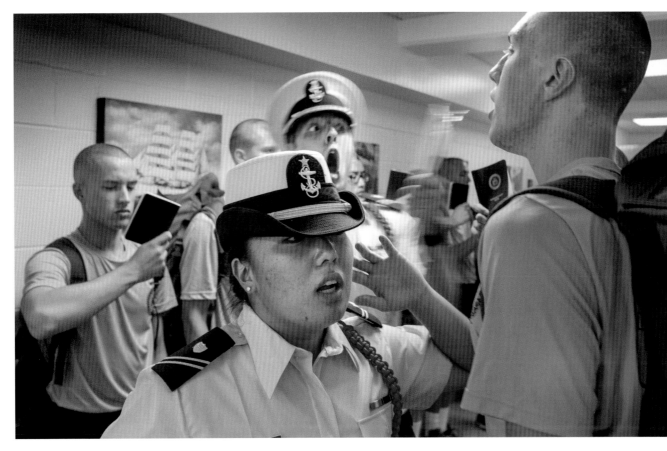

Above: Alyssa Sato (left) and Andrew Doyle try to get Swab Brendan Powell to sound off during his first-day training at the U.S. Coast Guard Academy in New London, Connecticut. Reporting Day is the first day of the seven-week student indoctrination, also known as Swab Summer, which assists in transitioning students from civilian life.

Left: New recruits line up for a group photo on the first day at the Coast Guard Academy. The academy was founded in 1876 and is one of five service academies in the country. Nearly 250 cadets enter the academy every summer.

Peter Ransom, class of 1950, sits in the Clark Chapel at Pomfret School. The school is located in the Pomfret Street Historic District and considered to be one of "Most Beautiful Boarding Schools Around the World" as ranked by *Town and Country Magazine*.

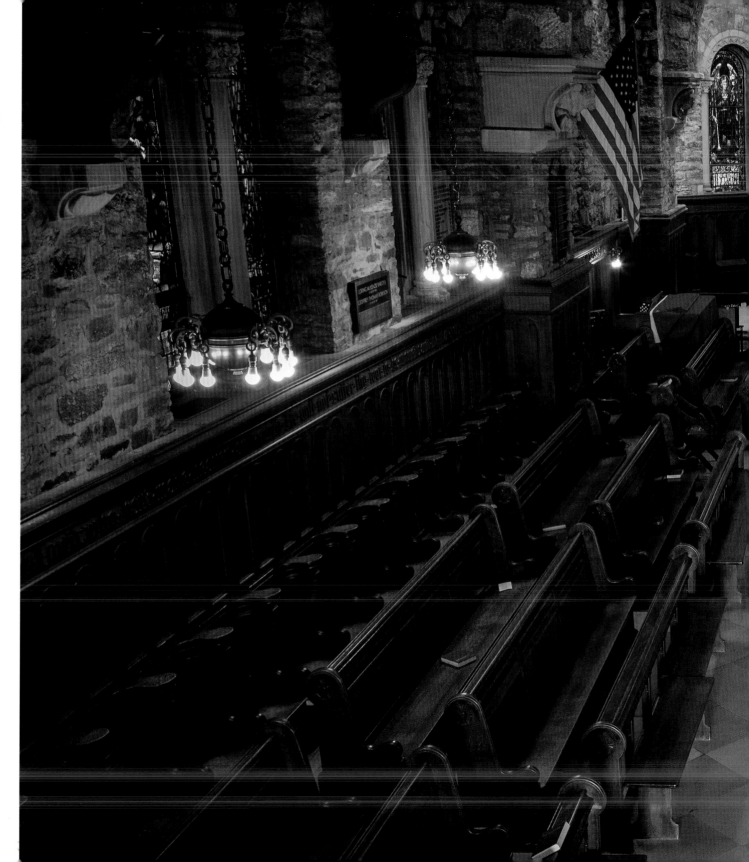

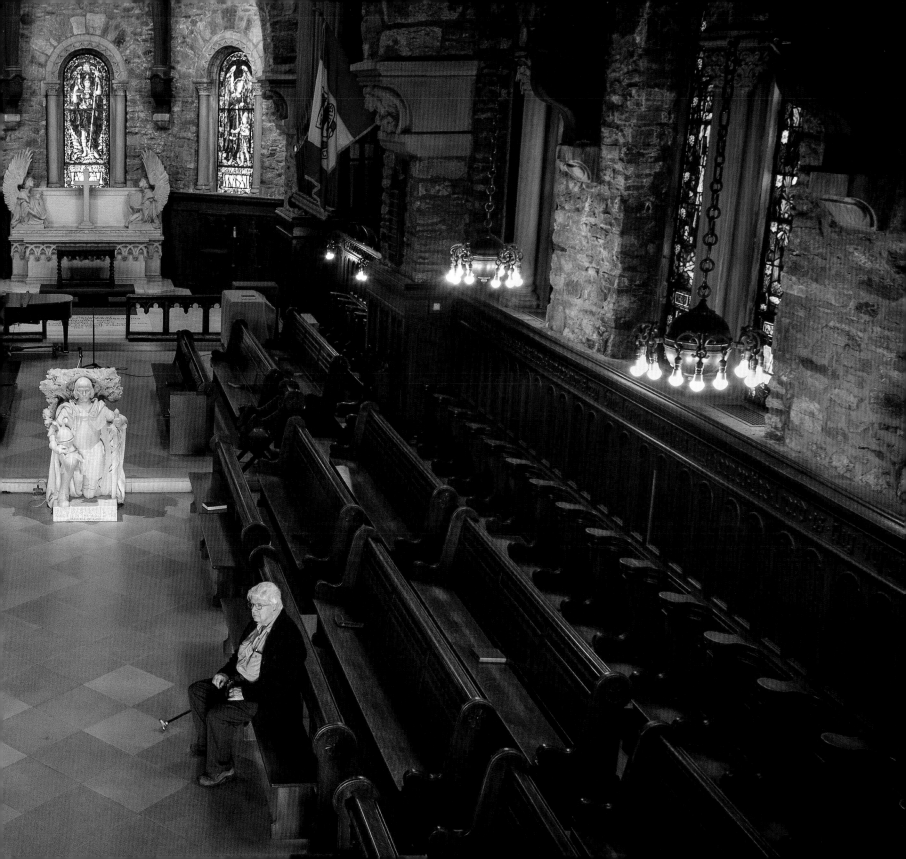

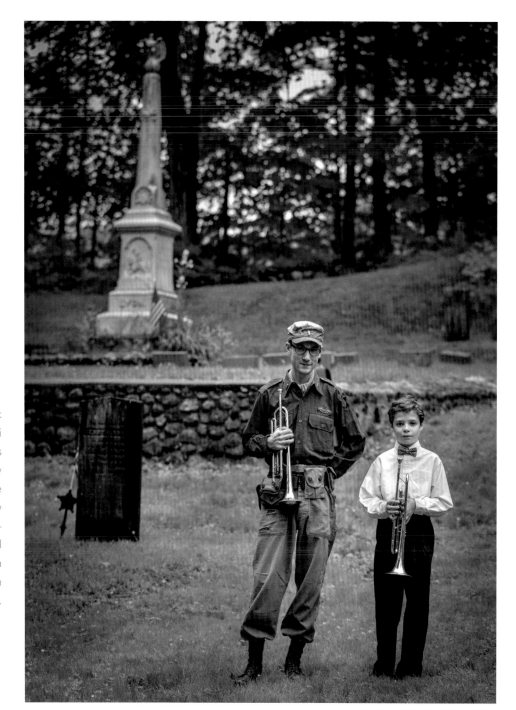

Robert C. Mackowiak (left) and Isaac Toreellini pause after playing taps at the Memorial Day activities at the General Lyon Cemetery in Eastford, Connecticut. General Nathaniel Lyon was the first Union general killed in the Civil War.

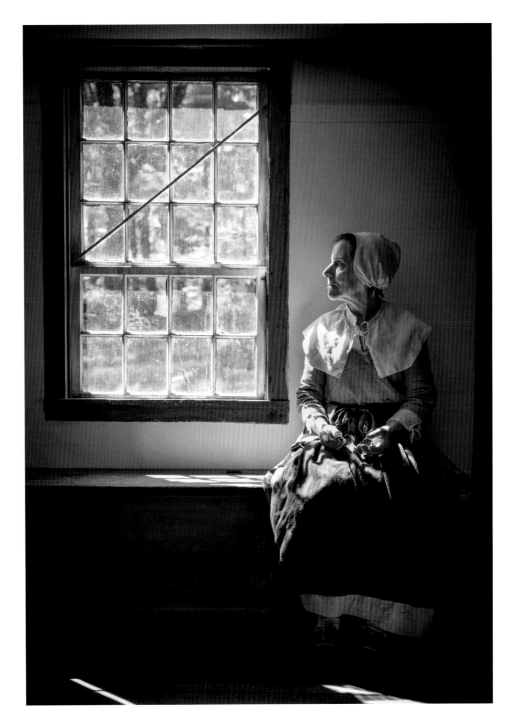

Gail White Usher waits for visitors at the Daniel Benton Homestead Museum in Tolland, Connecticut. The Benton House was built circa 1720 and has since been home to six generations of the Benton family. The small town's name is thought to have derived from a toll station along the route between Boston and New York.

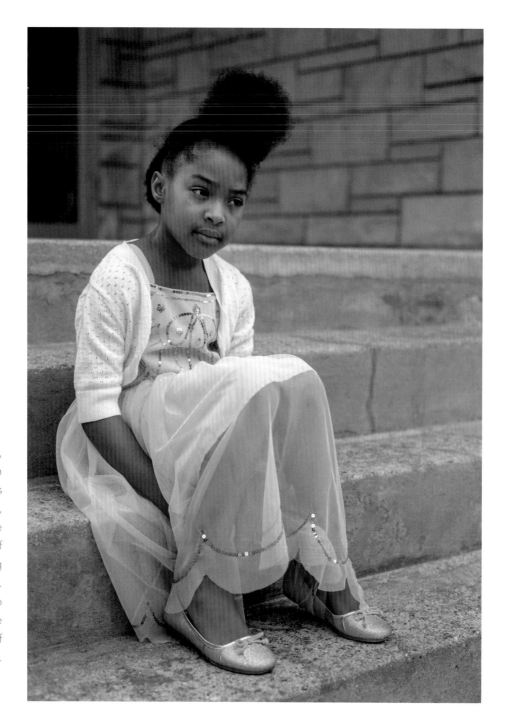

Dressed in her Sunday best, six-year-old Angeleah Pamphile waits for her parents after church in Norwich, Connecticut. The Pamphile family attends one of several French-speaking Haitian churches in Norwich. Many Haitians immigrated to the area after an earthquake devastated parts of their country.

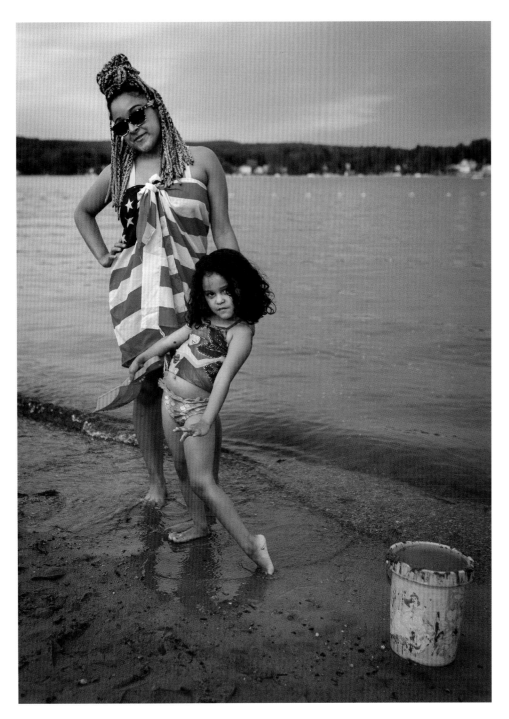

Celebrating the 4th of July, Xenia Gauthier and her mother, Lafield Rodrigues, are dressed in patriotic wraps at Webster Lake, Webster, Massachusetts. The town of Webster is located in Worcester County.

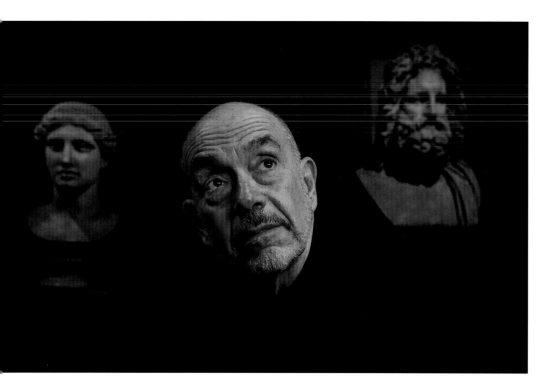

Above: Best-selling author Wally Lamb is photographed in the Slater Museum on the campus of Norwich Academy. Lamb is a Connecticut-based novelist who draws inspiration from his experiences growing up in Norwich, Connecticut. Places like the Slater Museum have been a source of his inspiration.

Right: Participants in the National Puppetry Festival prepare for a parade on the campus of the University of Connecticut in Storrs, Connecticut. The UConn Puppet Arts Program is one of the few such programs in the country. Work by graduates of the program is seen in many of the top theaters around the world.

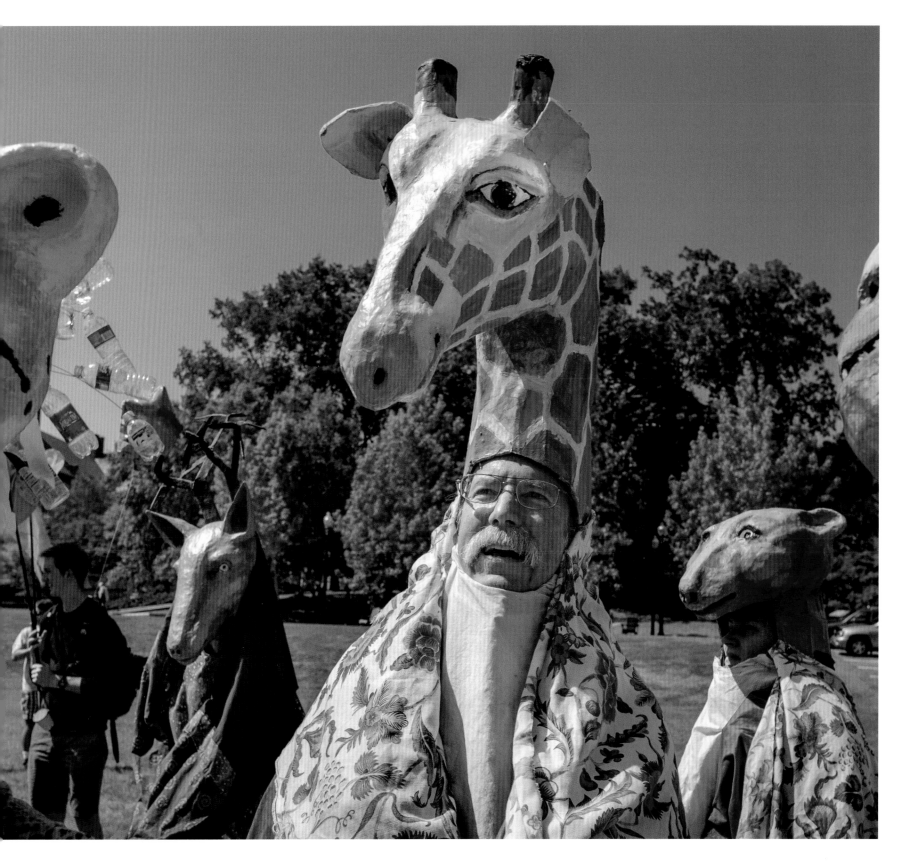

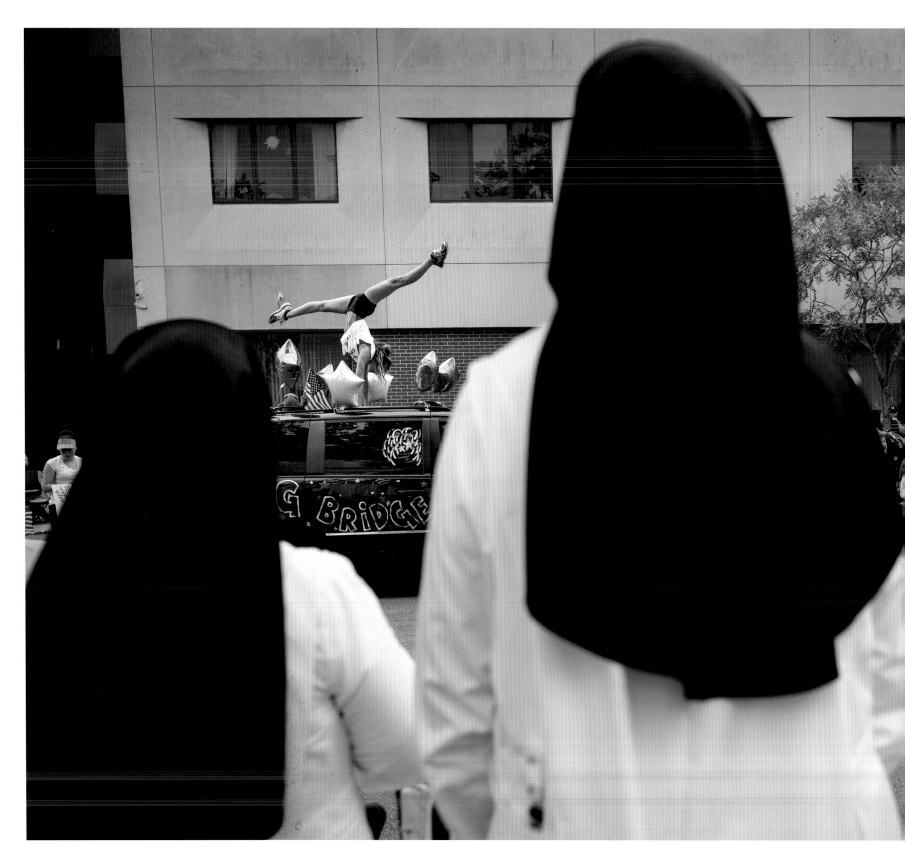

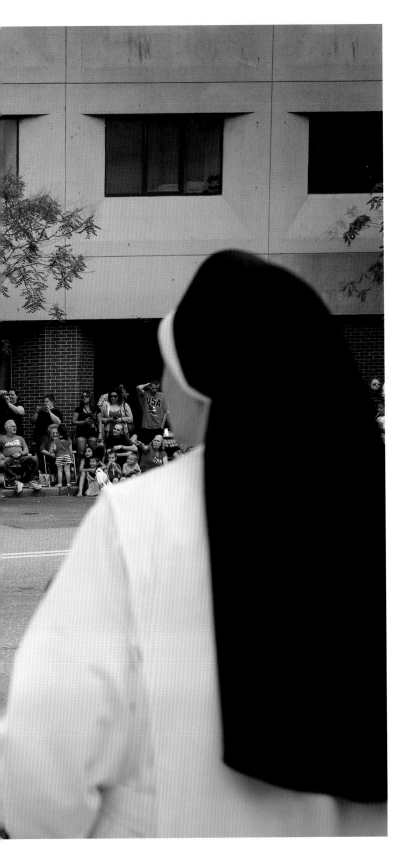

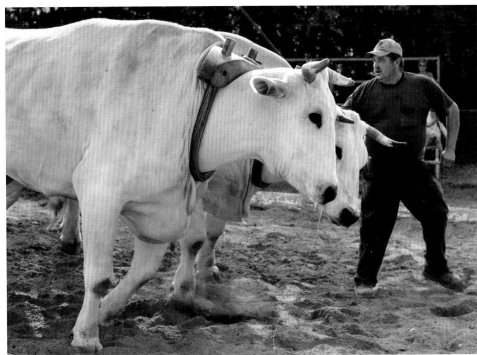

Above: Alan Rainville Jr. drives his oxen during the ox pull at the Brooklyn Fair in Brooklyn, Connecticut. Ox teams compete along with their owners to see which team can pull the heaviest load for six feet. Winning pairs pull as much as 20,000 pounds in one continuous movement. In the rolling hills of New England, oxen played a critical role in clearing the land and for farming.

Right: A group of nuns watches as a gymnastics performer works on a routine from the top of a car at the Boom Box Parade in Willimantic, Connecticut. The Boom Box Parade is an eastern Connecticut 4th of July tradition. The parade has no marching bands. Participants tune into the same local radio station and blast the music.

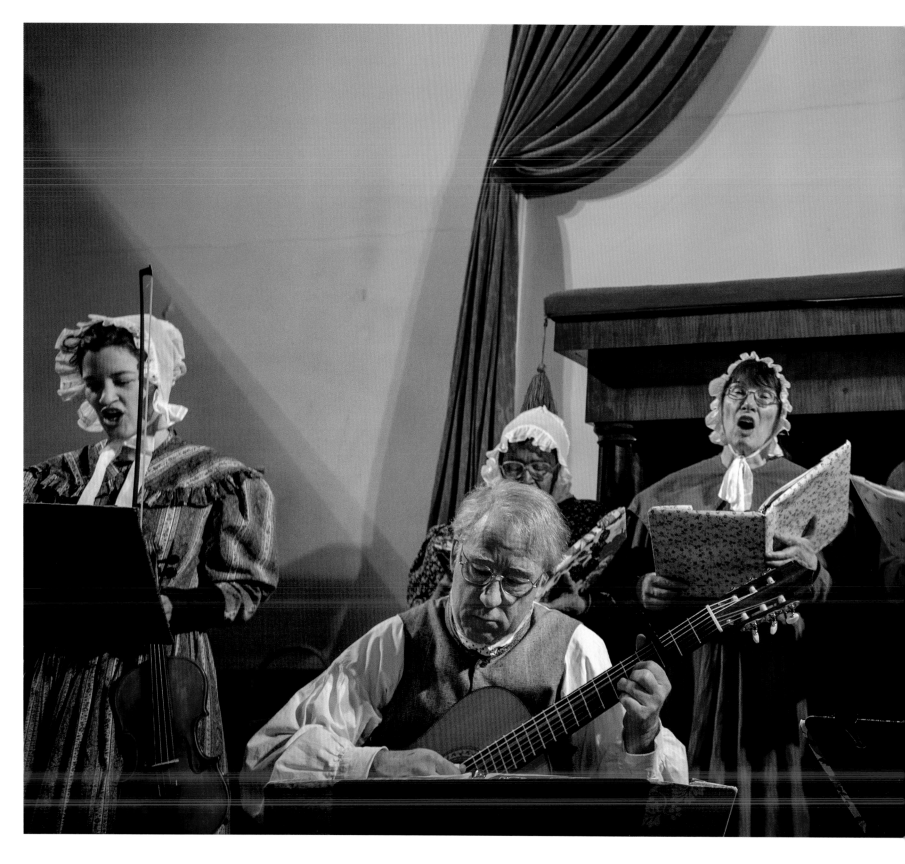

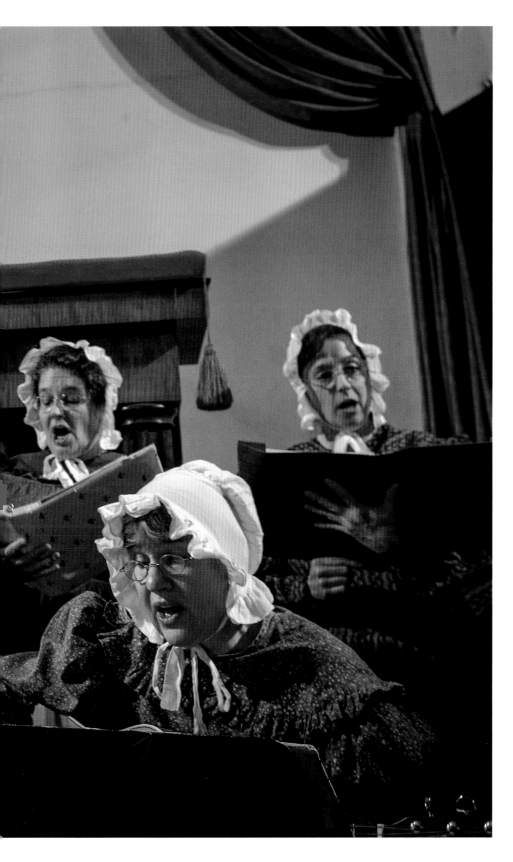

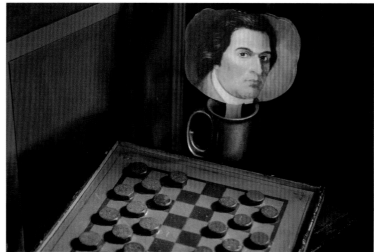

Above: A hand fan with a portrait of Benedict Arnold sits alongside a checkerboard at Leffingwell House Museum (built circa 1675) in Norwich, Connecticut. Benedict Arnold was a general in the American Revolutionary War who defected to the British Army. Arnold grew up in Norwich along the banks of the Thames River.

Left: The Sturbridge Village Singers sing Christmas carols to a crowd at the Center Meeting House in Sturbridge, Massachusetts. The building was built as the Baptist Meetinghouse in Sturbridge in 1832. Old Sturbridge Village is a living history museum located in Sturbridge, Massachusetts. The museum grew out of the Wells family's antique collection and celebrates 19th-century New England traditions.

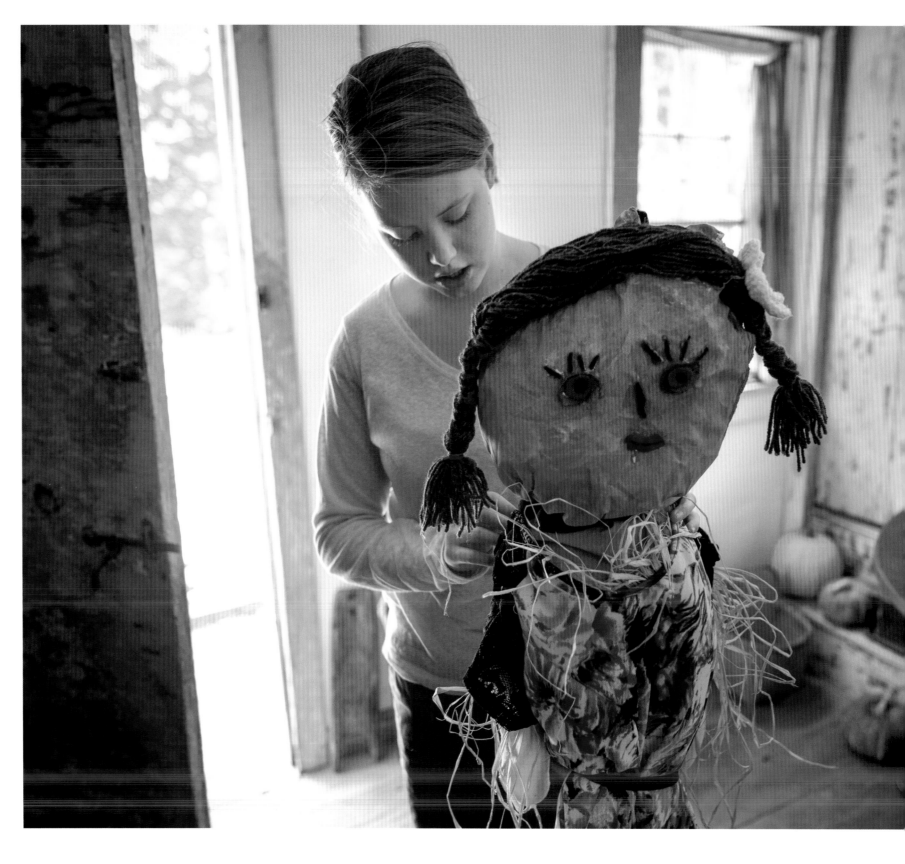

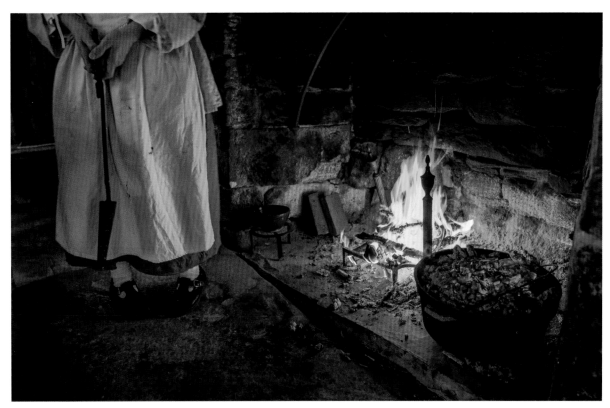

Above: Tina Mazza cooks using the old school traditions of hearth cooking in the kitchen of the Huntington Homestead, in Scotland, Connecticut. Samuel Huntington signed the Declaration of Independence. The property is a National Historic Landmark.

Left: Audrey-Anne Pothier, thirteen years old, puts the finishing touches on her entry into the scarecrow contest at the Huntington Homestead in Scotland, Connecticut. The homestead was the birthplace of Samuel Huntington. Huntington served as president of the Continental Congress from 1779 to 1781, chief justice of the Connecticut Supreme Court, and governor of Connecticut.

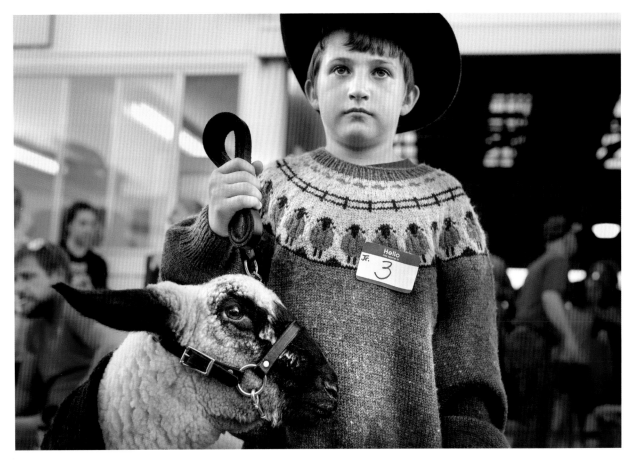

Above: Connor Priest gets his game face on as he prepares to enter the ring to show his sheep at the Woodstock Fair in Woodstock, Connecticut. The Pomfret Agricultural Society was formed in 1809 and it included the Woodstock, Brooklyn, and Pomfret communities.

Left: Luis Lopez runs a fabric tacker at the American Woolen Company in its Stafford Springs factory. American Woolen Company is the only remaining garment factory in the valley. New England was once the center of the American garment industry.

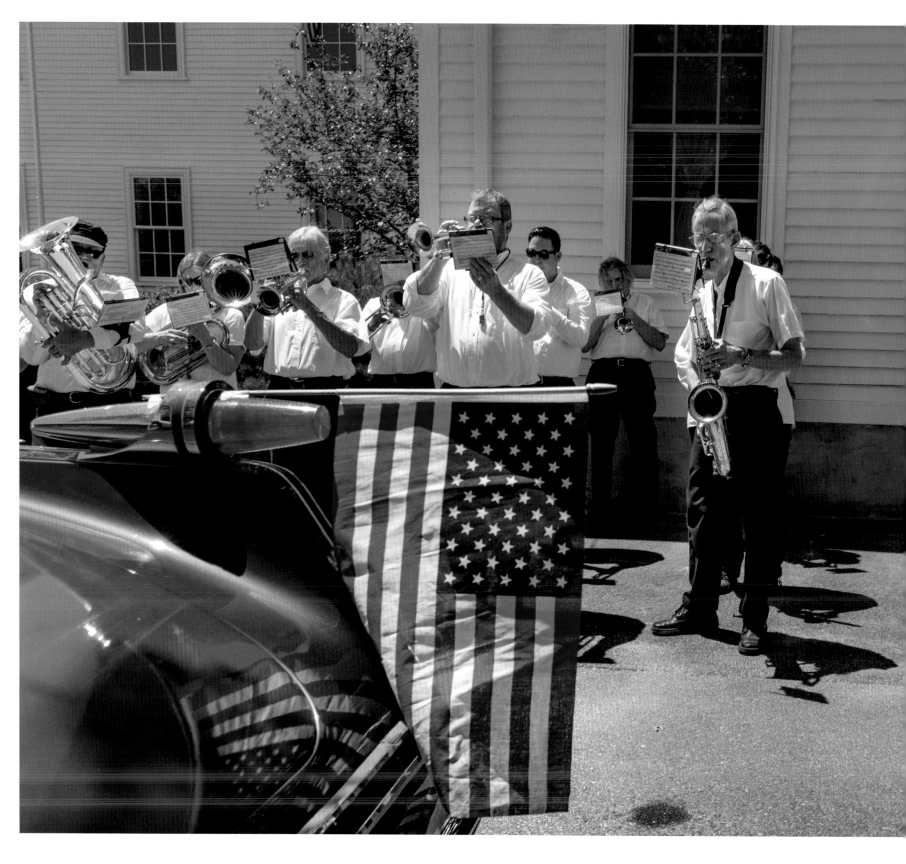

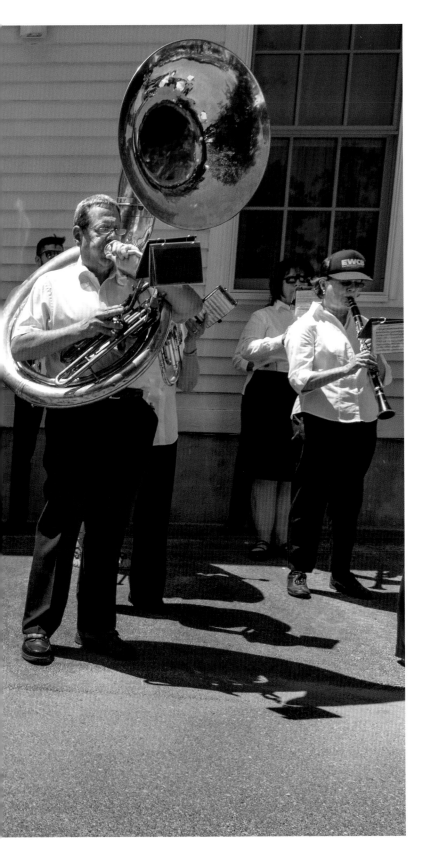

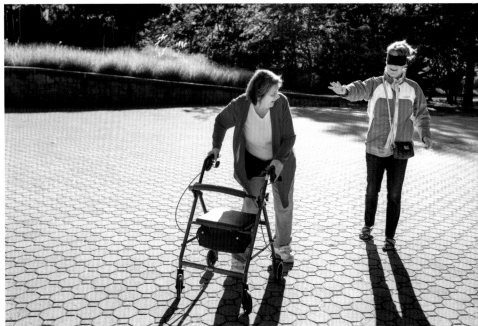

Above: Cynthia Litton leads Dianne Brown as she walks with a blindfold at the Mohegan Park Wilderness in Norwich, Connecticut. The two were participating in the Walktober event "In the Shoes of the Seeing Impaired." The Last Green Valley sponsors Walktober events as a way to get out and enjoy the National Heritage Corridor.

Left: The East Woodstock Cornet Band plays at the Fourth of July Jamboree on the Common in East Woodstock, Connecticut. Although Woodstock is not densely populated, it covers over sixty square miles and is second largest town in Connecticut.

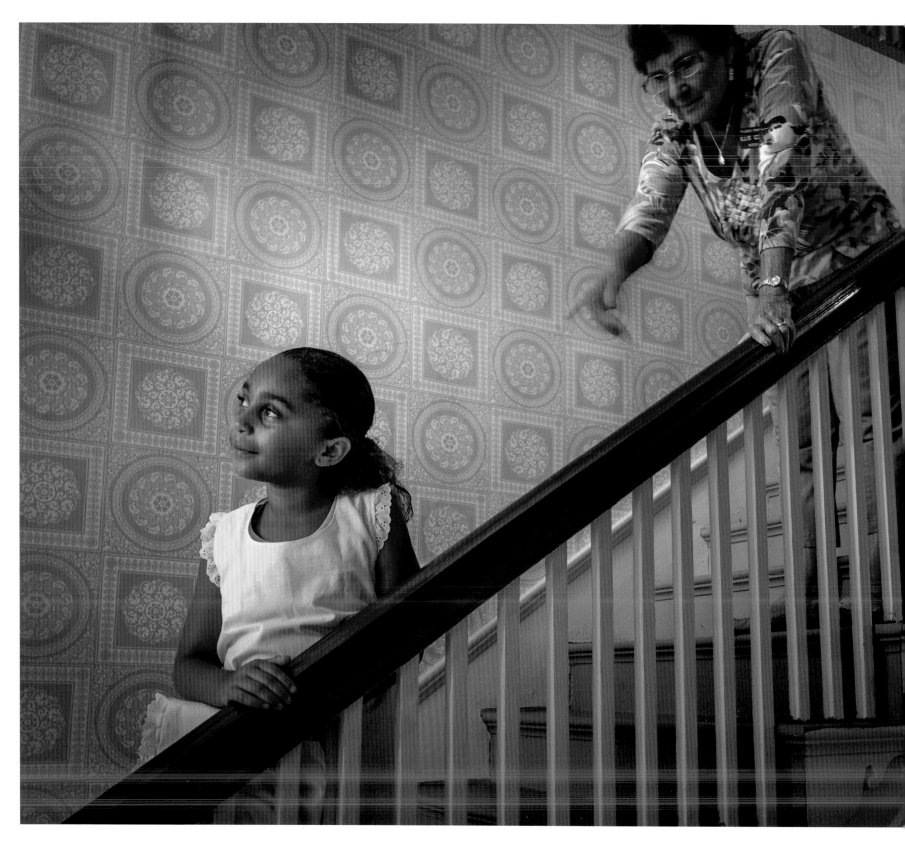

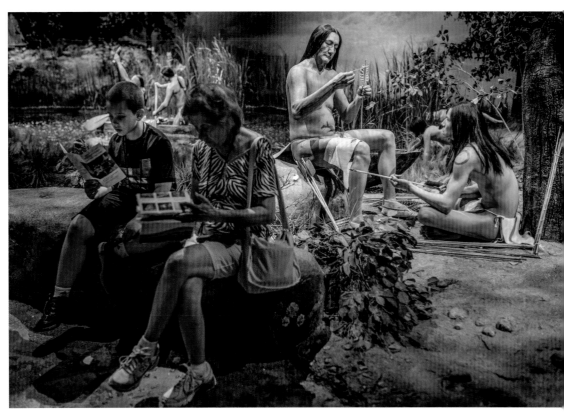

Above: Visitors stop and read museum material in front of the dioramas at the Mashantucket Pequot Museum at the Mashantucket Pequot Tribal Nation, Connecticut. The museum has over 300,000 square feet dedicated to the history and cultures of the native peoples of North America.

Left: Carmen Hall, eight, pauses as she walks up the stairs at the Prudence Crandall Museum in Canterbury, Connecticut. Prudence Crandall was a Connecticut schoolteacher and Quaker who, in 1833, opened the Prudence Crandall School for African American girls. Today, Crandall is considered a Connecticut heroine for her bravery in standing up to racial discrimination.

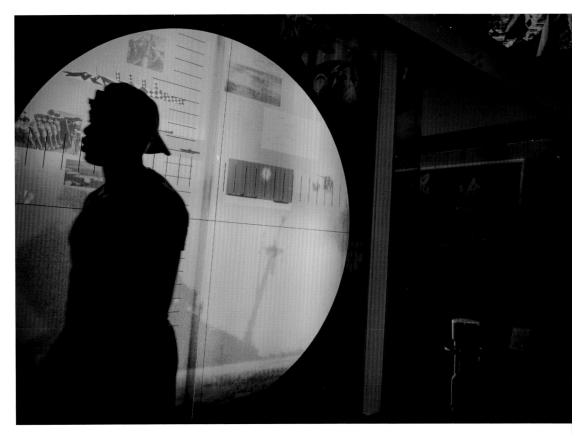

Above: A visitor passes in front of a display at the Submarine Force Museum in Groton, Connecticut. Groton is located at the mouth of the Thames River and is considered a hub for American submarine activity.

Left: A Japanese "type A" two-man submarine lies landlocked in a flower garden at the museum. The area is home to the Electric Boat Corporation, a major contractor for submarine work for the United States Navy. The Naval Submarine Base New London is also located in Groton.

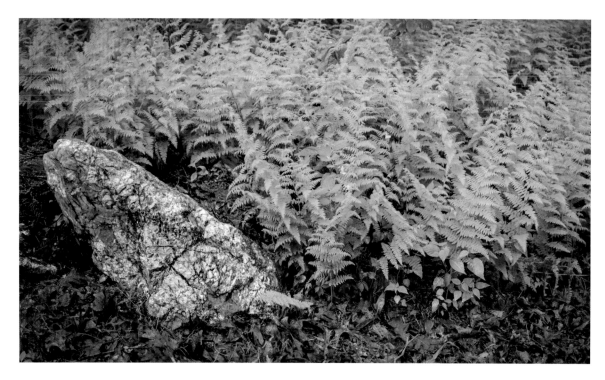

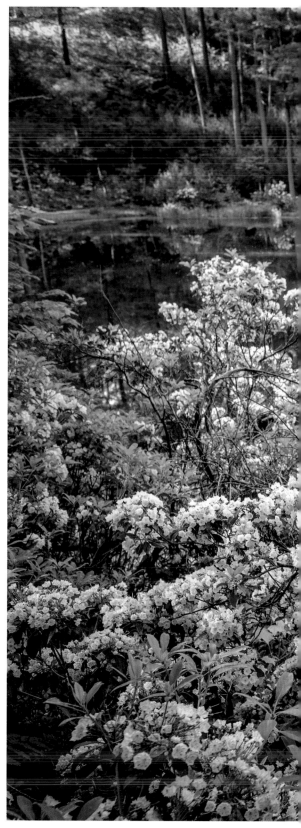

Above: A piece of granite lies in the midst of a large stand of ferns deep in the Pachaug State Forest. The Pachaug State Forest covers over 24,000 acres and is Connecticut's largest state forest. The Pachaug River runs through the forest from the Rhode Island border area. The Pachaug River makes its way to the Quinebaug River.

Right: Connecticut's state flower, the Mountain Laurel, grows wild in much of the area. The Mountain Laurel is an evergreen shrub that is native to the east coast. Early immigrants brought the beloved but poisonous plant to Europe in the 1700s.

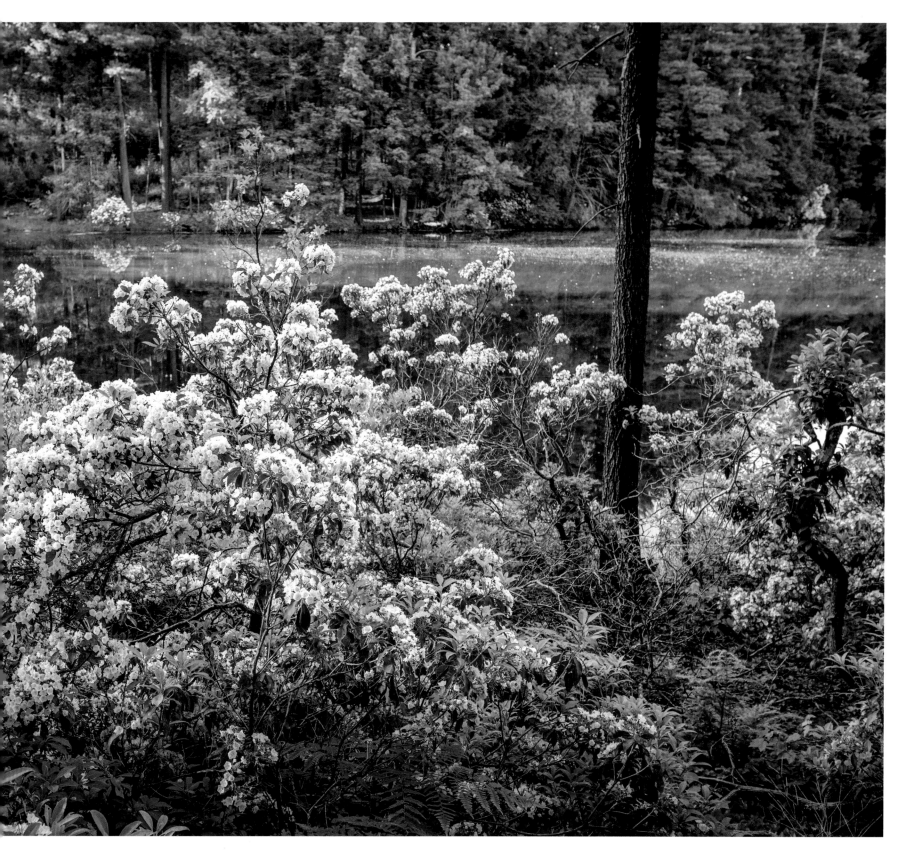

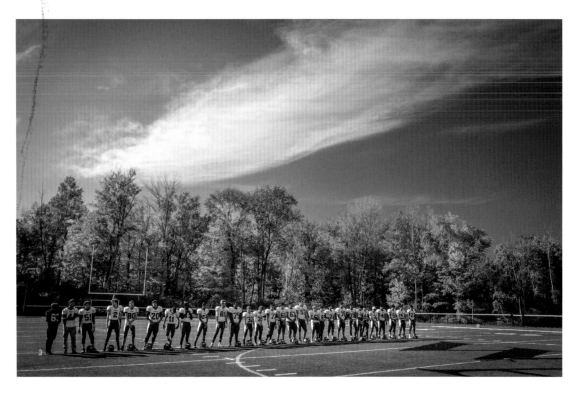

Above: With fall colors as a backdrop, the Windham High School football team lines up before the game against Woodstock Academy. Windham High School is located in Willimantic, Connecticut.

Right: An old stone wall fence line peers out of the fall-colored forest in Nipmuck State Forest near Union, Connecticut, along the Massachusetts border. Early immigrant farmers created the stone walls while clearing the land for farming. Today, many of these walls have become overtaken by the forest. These walls stand as a reminder of New England's agricultural heritage.

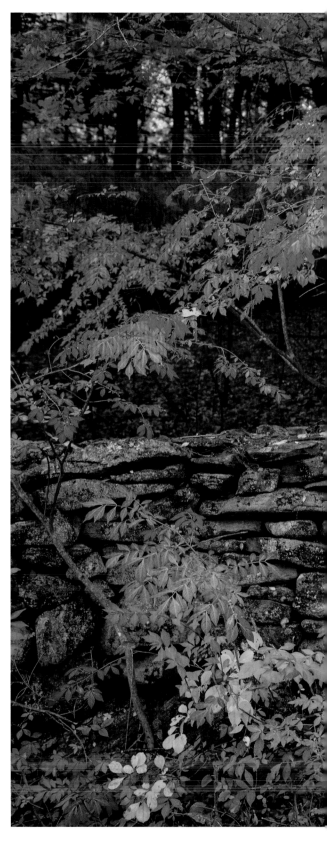

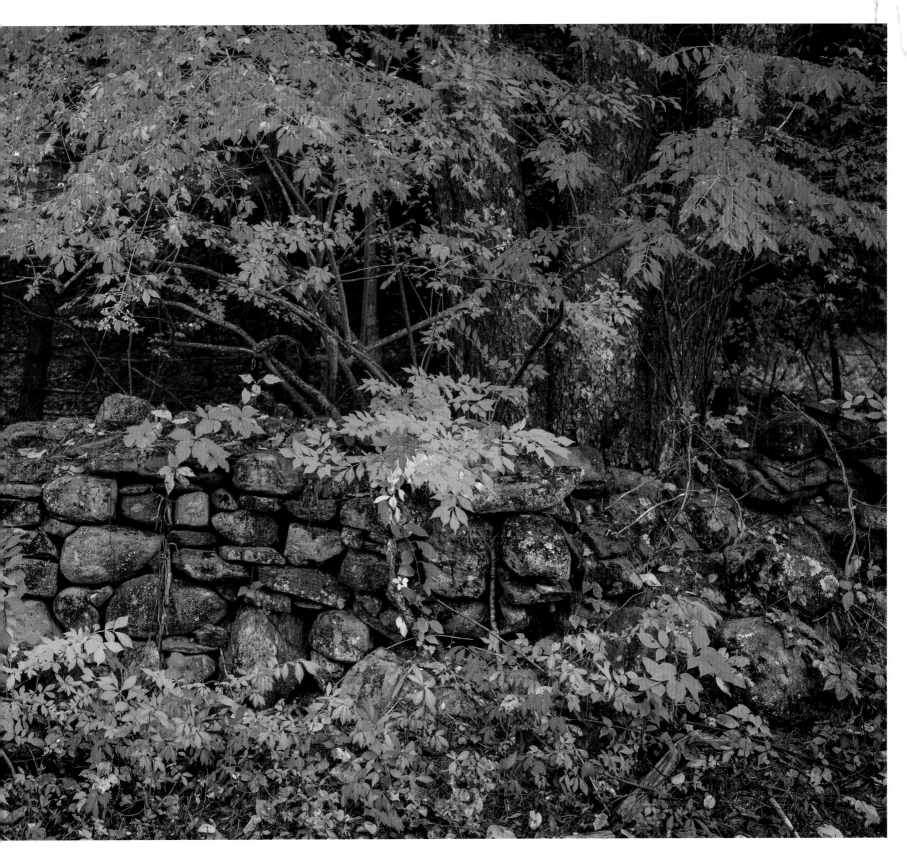

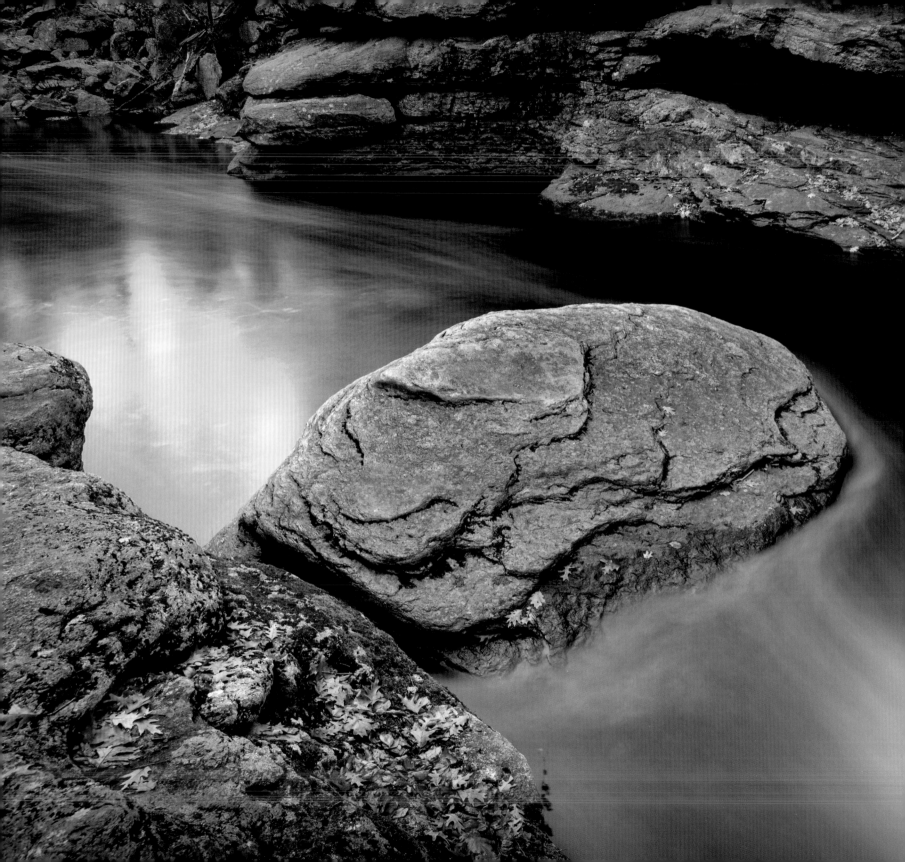

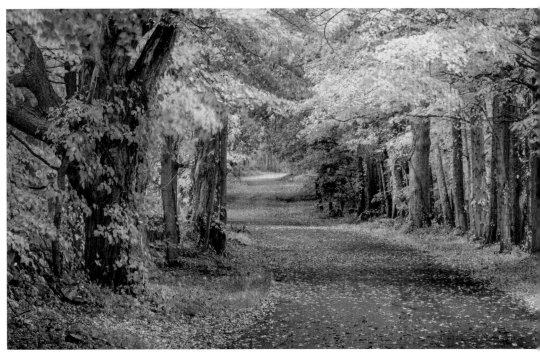

Above: Fall colors make a pathway of yellows and greens in Ashford, Connecticut. Ashford is known for its camps that take advantage of remote forest locations. It is the home of the June Norcross Webster Scout Reservation, the Salvation Army Connri Lodge, the Hole in the Wall Gang Camp founded by Paul Newman, and the Evangelical Christian Center.

Left: Diana's Pool, located in Chaplin, Connecticut, is a series of small pools and waterfalls carved over the centuries by the Natchaug River. The Natchaug River begins as the Still River, and Bigelow Brook converges south of Phoenixville. The "Natchaug" is a Native American term for "land between the rivers."

Following: Cornfield stubble and a cold winter's wind grip the New England landscape on a small farm along Highway 44 near the Natchaug State Forest. This section of New England was once cleared of its forest for farmland. Today, the deciduous forest dominates this hilly landscape, having reclaimed the vast majority of the farmland.

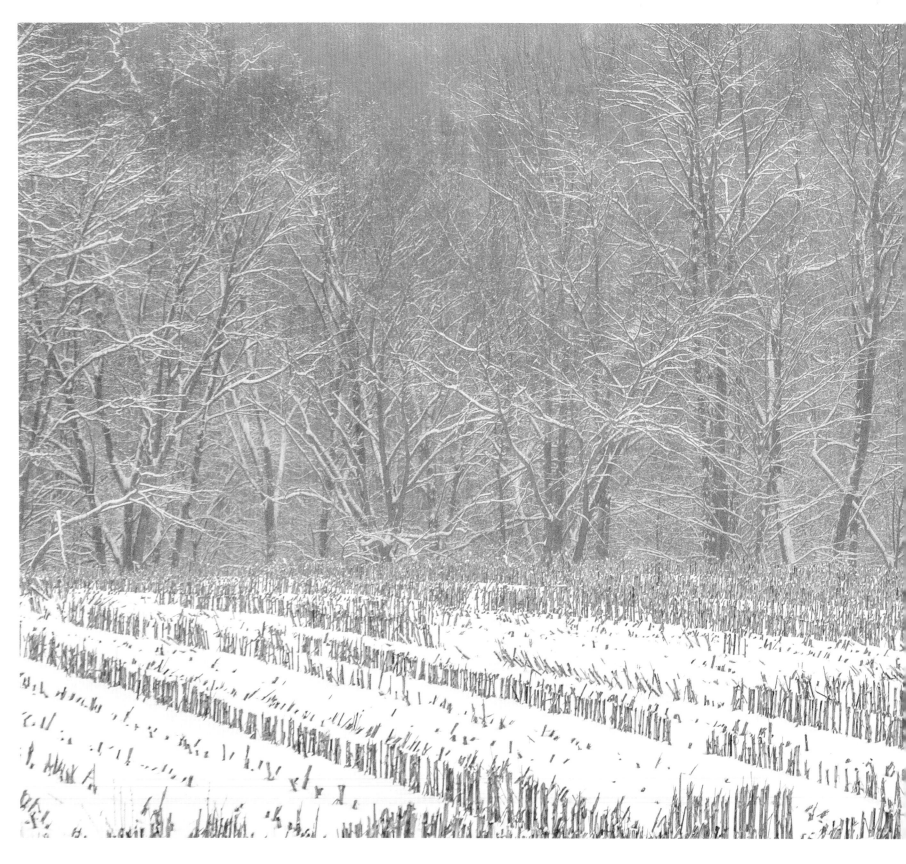

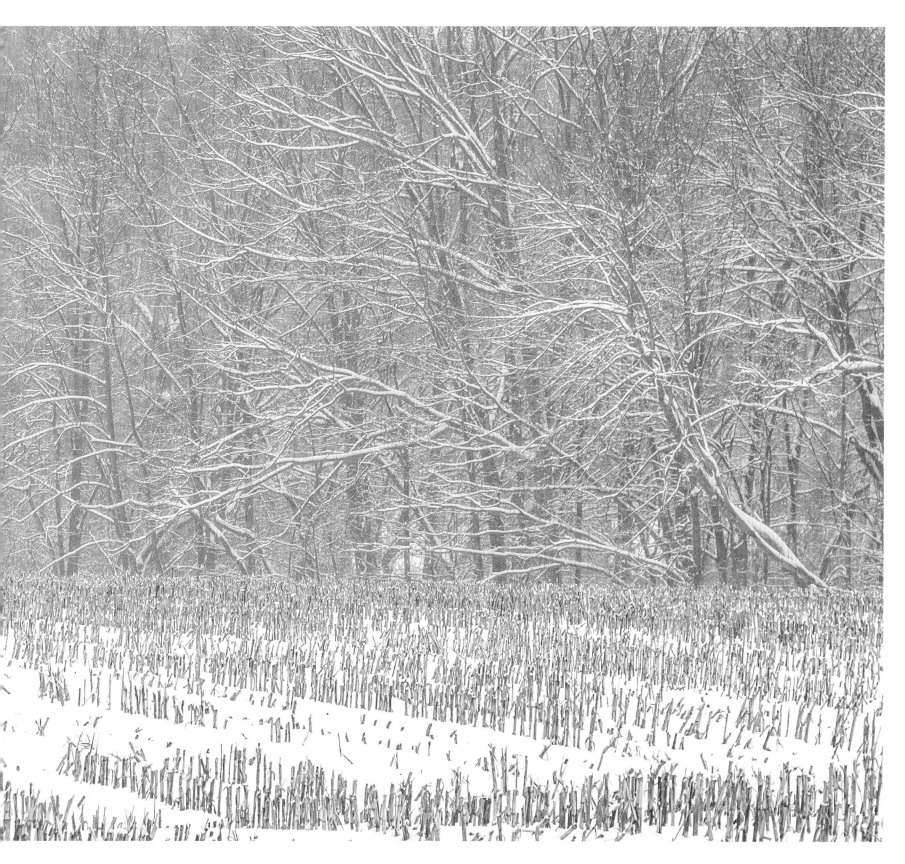

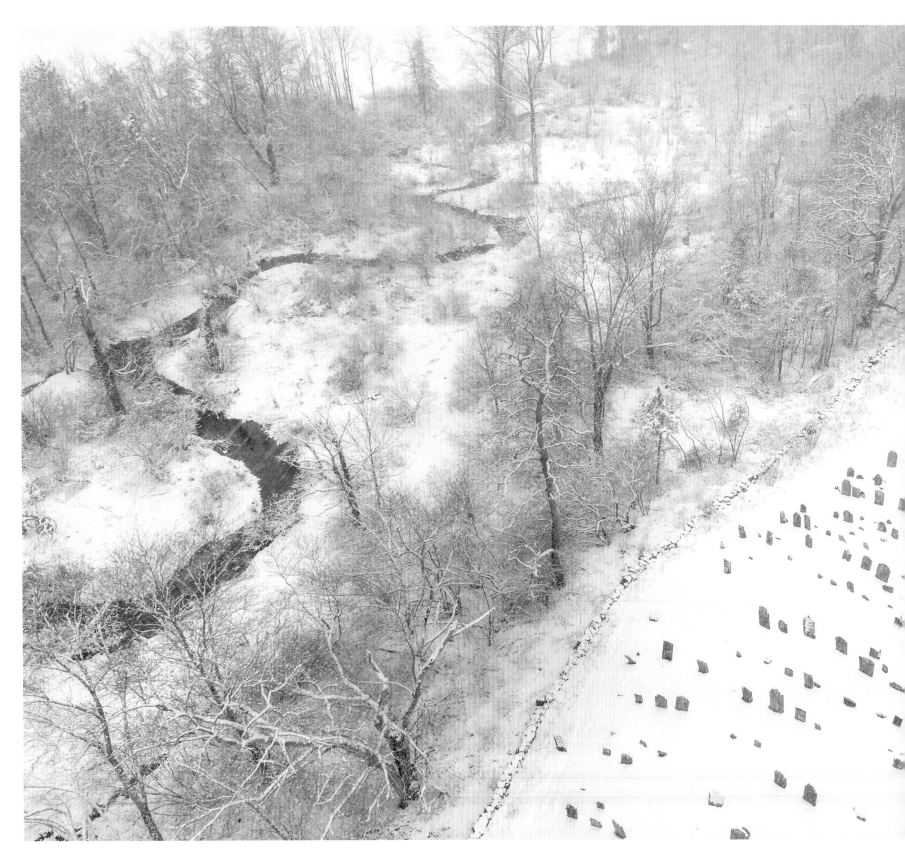

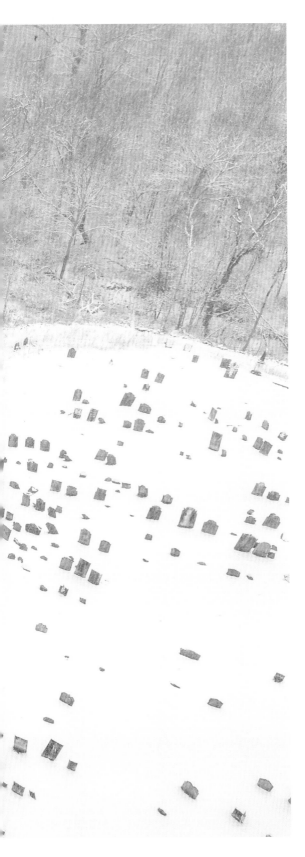

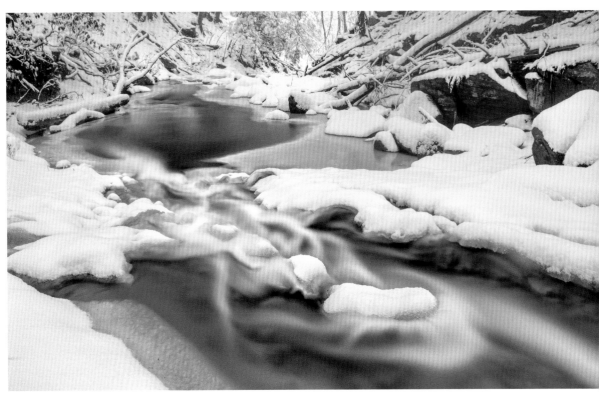

Above: A soft winter's snow covers Tinkerville Brook in Ashford, Connecticut. Tinkerville Brook Preserve is part of the Joshua's Tract Conservation and Historical Trust. Joshua's Trust is the largest land trust in the area, protecting and preserving over 4,000 acres.

Left: Susquetoncut Brook runs alongside the Trumbull Cemetery in Lebanon, Connecticut. Several founders of our nation are buried here, including Revolutionary War Governor Jonathan Trumbull and William Williams, a signer of the Declaration of Independence. Trumbull graduated from Harvard in 1727 and was governor of both the colony and the state of Connecticut.

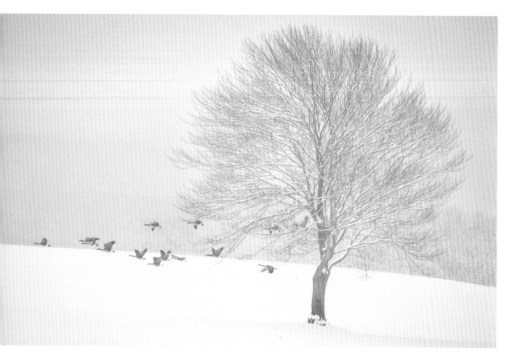

Above: A timeless winter scene plays out on the rolling hills near Pomfret, Connecticut, as a flock of Canadian geese fly by a leafless tree. Farming was a staple for this area of Connecticut; early settlers worked tirelessly to clear the deciduous forest from the land.

Right: A couple walks hand in hand on the University of Connecticut's Storrs campus. The university is a public land-grant research university established in 1881. Authors Howard and Matthew Greene labeled the university as "Public Ivy" in 2001 for the school's academic traditions.

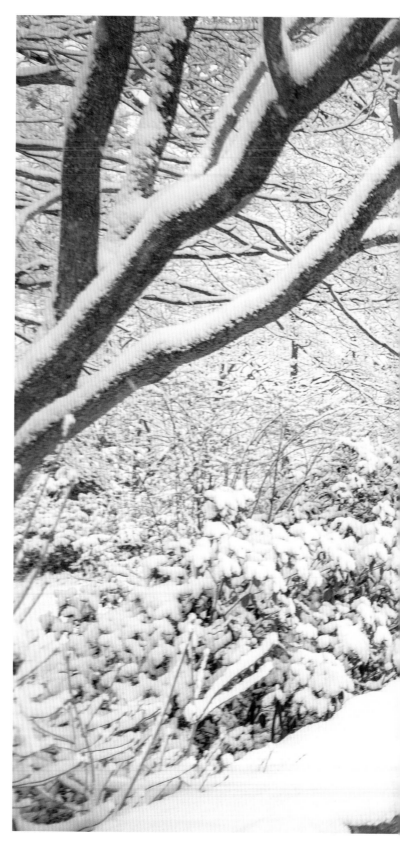

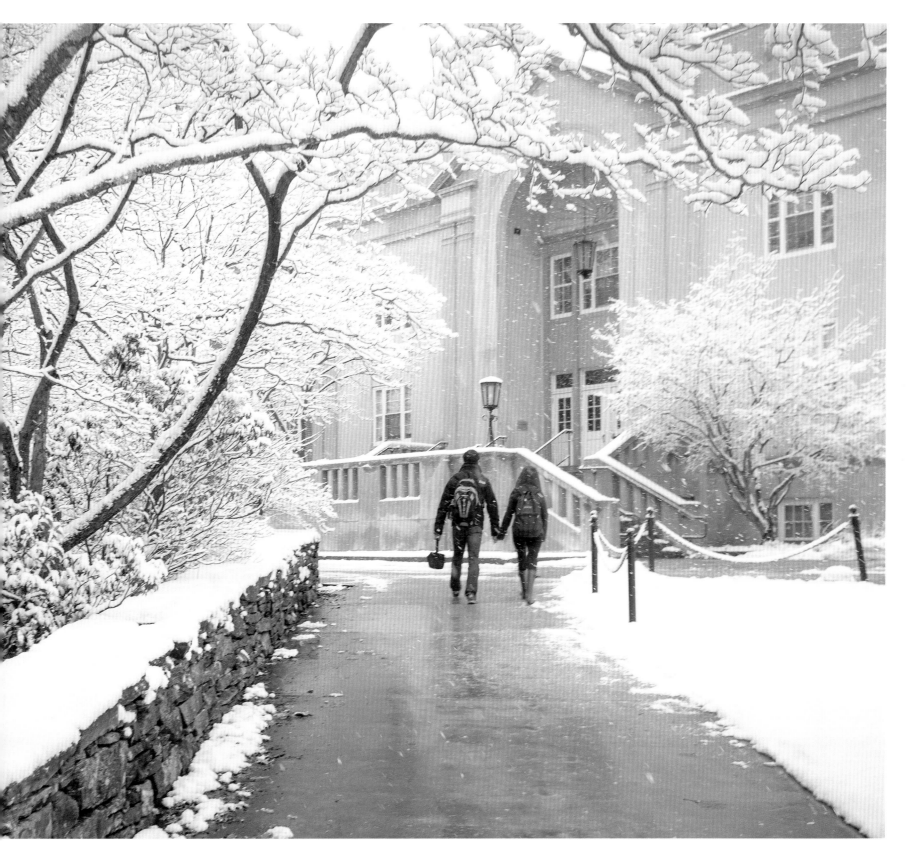

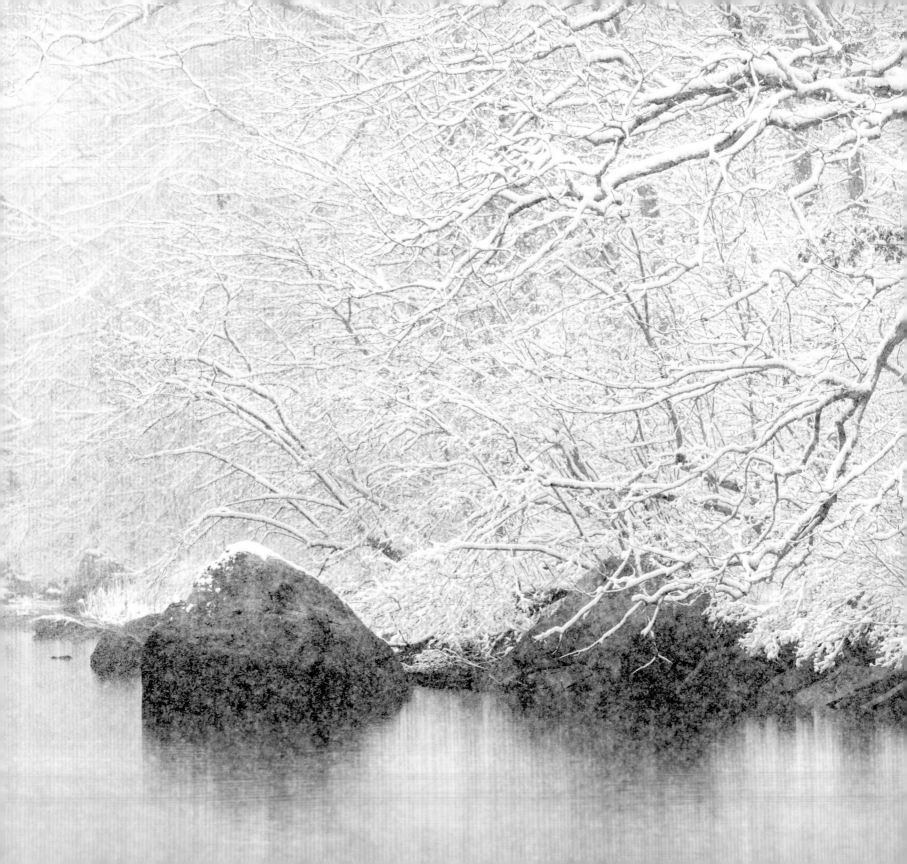

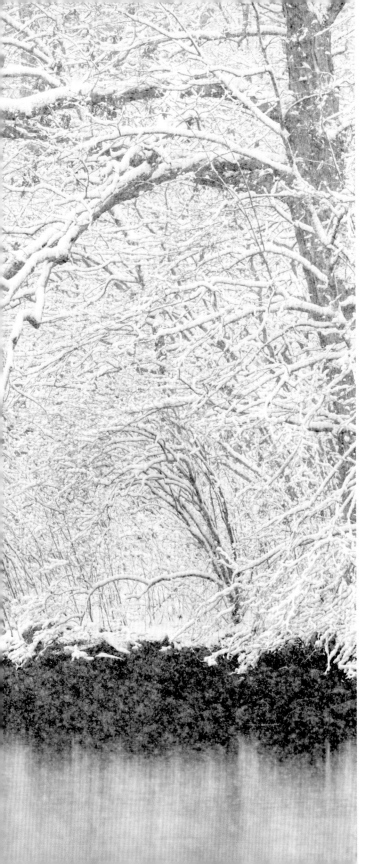

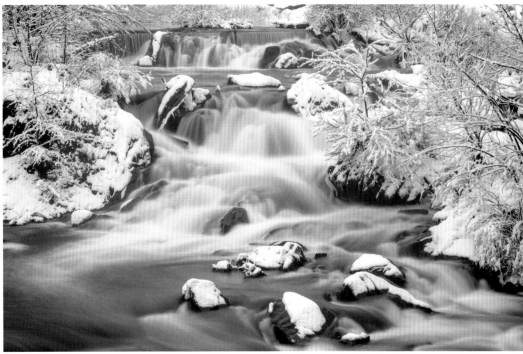

Above: Cargill Falls is located in downtown Putnam, Connecticut. The falls are created by an old dam used by the historic Cargill Falls Mill. The mill, which is listed in the National Register of Historic Places, is considered the first mill in Connecticut to have produced cotton broadcloth.

Right: The Thames River is a tidal estuary that has provided important harbors since the mid-17th century. The river was previously known as the Pequot River. In 1658 the harbor town of New London was officially named, and the river subsequently renamed.

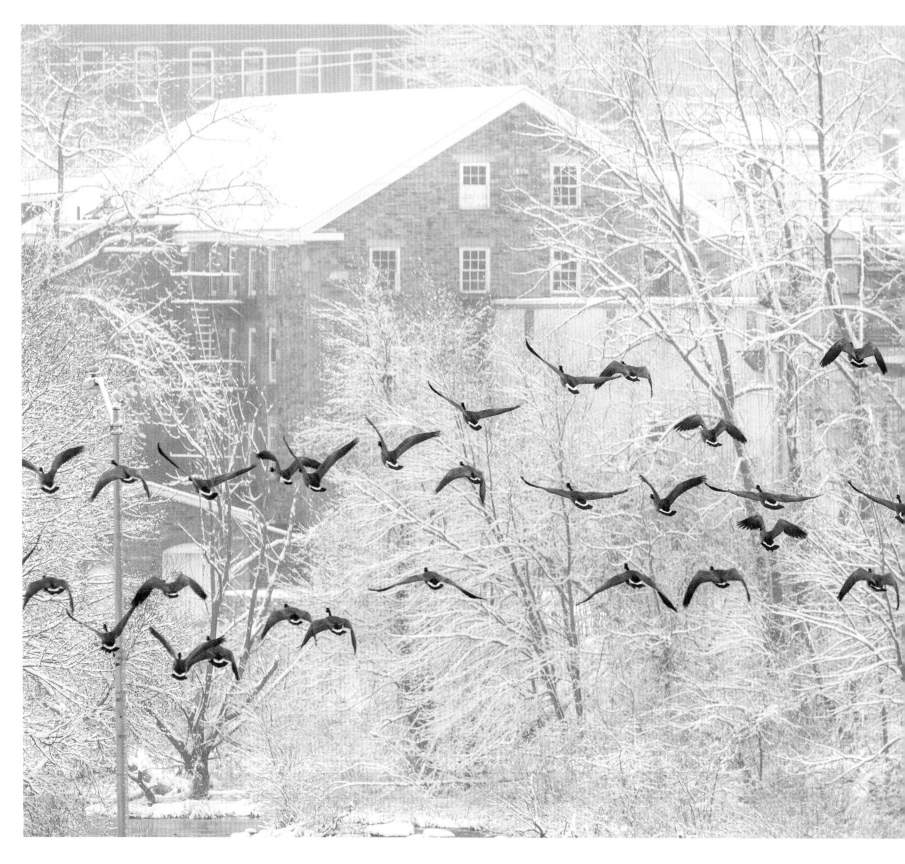

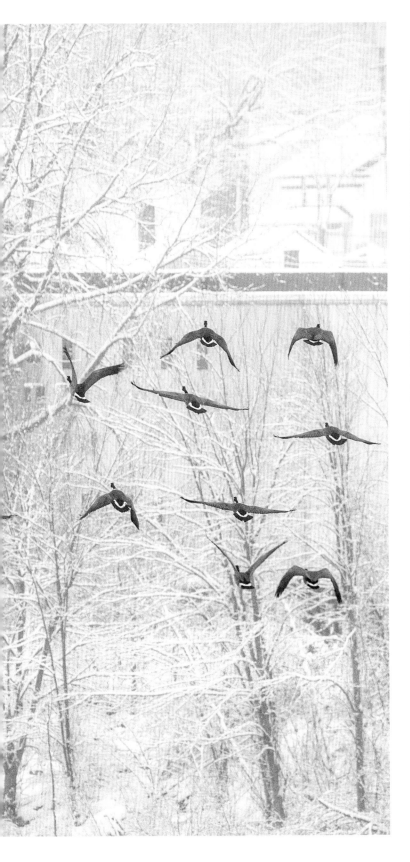

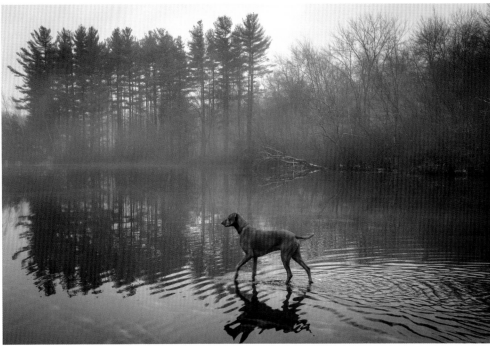

Above: A pointer stands on a small ice-covered rainwater pond in Tolland, Connecticut. New England is well known for winter temperatures that hover around freezing, creating some unusual ice and rain conditions.

Right: A flock of geese rises along the riverbanks lined with old mill buildings in Putnam, Connecticut. Putnam is an old New England mill town that has been rejuvenated by converting its old buildings into centers for antiques and lofts.

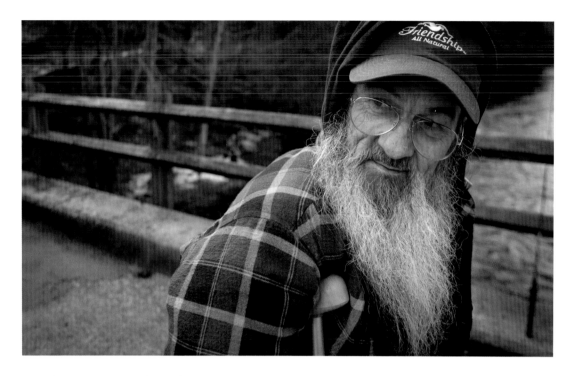

Above: Dennis Ferland of Danielson, Connecticut, walks along an old bridge in the Natchaug State Forest near Phoenixville, Connecticut. The Natchaug River Bridge opened in 1934 and was built by the boys of Camp Fernow of the Civilian Conservation Corps. According to the Department of Energy and Environmental Protection, Connecticut had 21 CCC camps, including Company 183 at Camp Fernow, located in Natchaug State Forest. The camp opened in June of 1933 and closed in May 1941. The bridge is currently in a state of disrepair and is closed to vehicle traffic.

Right: Beach Pond is a nearly 400-acre lake that straddles the Connecticut/Rhode Island border. The lake is one of the easternmost points of the Thames Watershed. The Pachaug River flows out of the westernmost end of Beach Pond. The Pachaug River flows for sixteen miles before intersecting with The Quinebaug River.

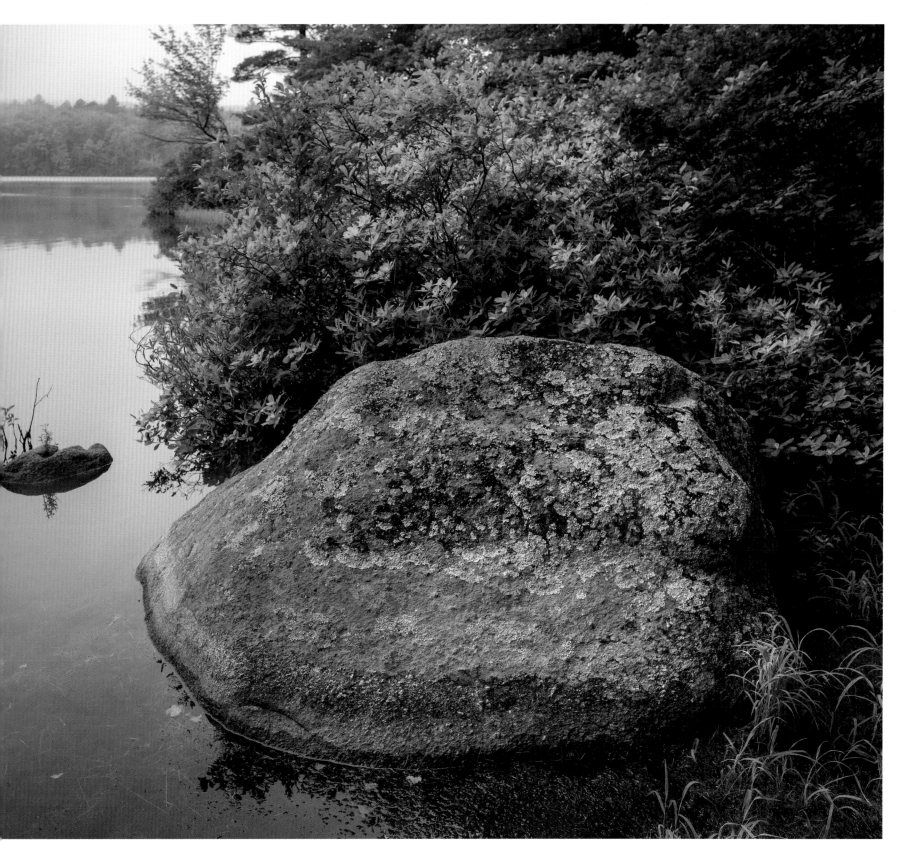

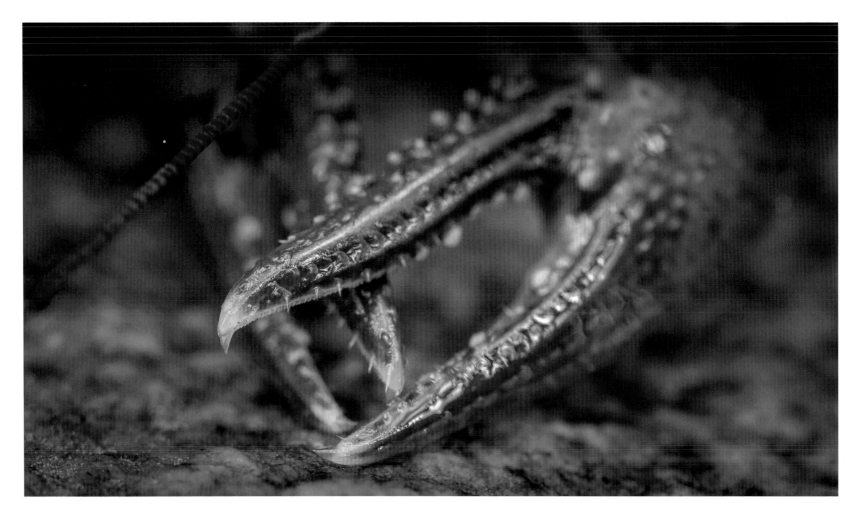

A detailed close-up of the pinchers of a crayfish photographed in the Willimantic River in Mansfield, Connecticut. There are over 330 species of crayfish in North America. These freshwater crustaceans resemble small lobsters to which they are related. This species is found in small streams where there is fresh running water. This type of crayfish does not tolerate polluted water well. The Northern Crayfish has a pair of claw-bearing pinchers that extends in front of its body. These strong chelipeds are specialized for protection and capturing food.

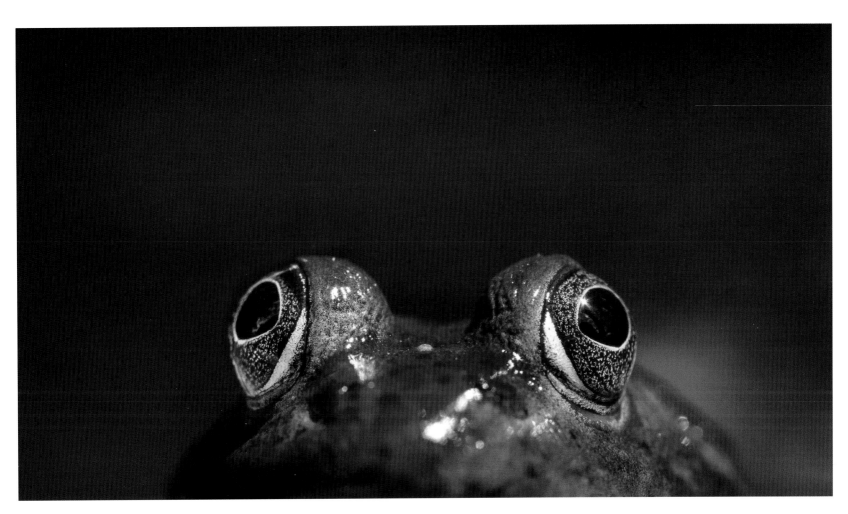

A portrait of a Green Frog in a small pond in Merrow Meadow Park in Mansfield, Connecticut. Green frogs have large protruding eyes, giving them almost 360-degree vision. This distinct feature is an important attribute, as frogs do not have very flexible necks. Their excellent peripheral vision helps them spot predators and prey. Though mainly solitary, during the breeding season, these frogs congregate in small ponds and produce a number of distinct calls.

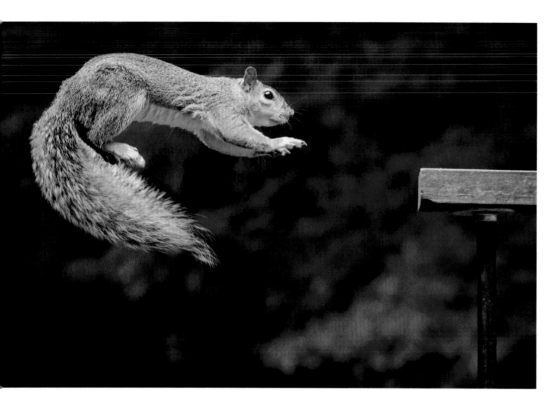

Above: An acrobat of the forest, a gray squirrel, jumps to a piece of timber, looking for an easy meal. The eastern gray squirrel is one of the most common wild mammals in Connecticut. Squirrels use their oversized tails as counterbalances to help them perform their aerialist's feats.

Right: A northern cardinal to keeps a wary eye out for predators. The lush deciduous forest of the valley provides an exceptional habitat for a vast selection of songbirds. Cardinals prefer to live on the edge of the forest; the males are very territorial and like to perch in the high branches to keep an eye on their domain.

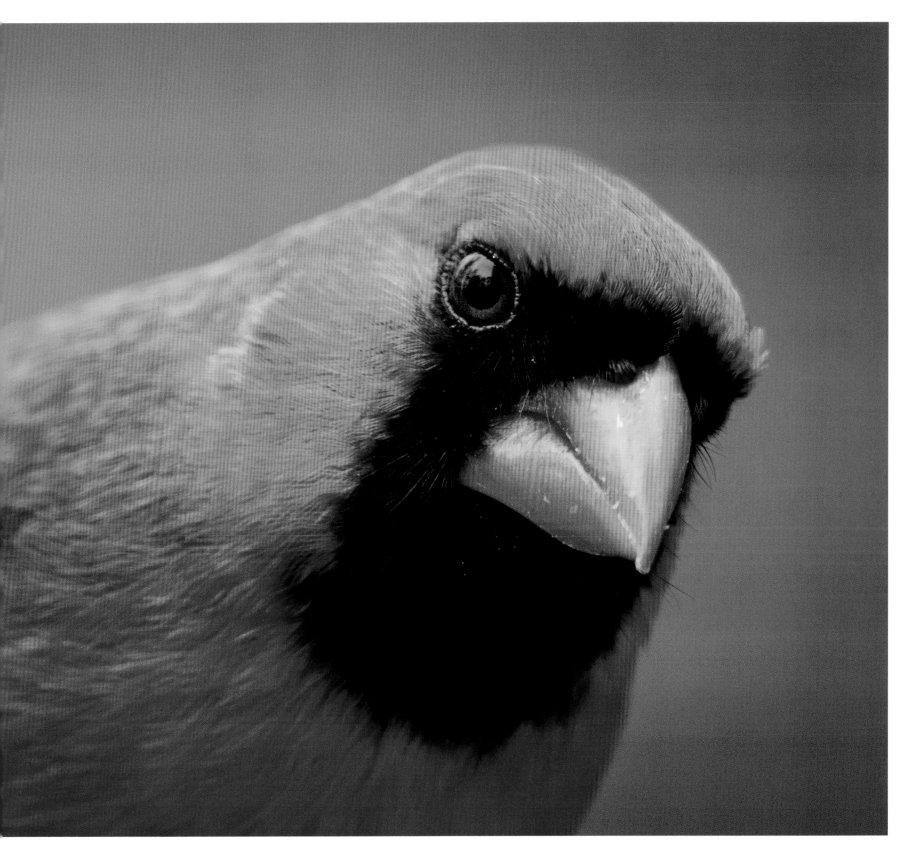

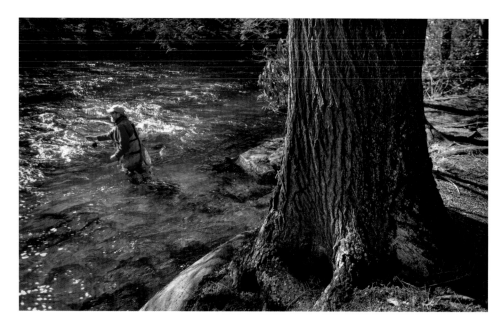

Above: Jim Hamle of East Killingly, Connecticut, fly fishes along the banks of the Natchaug River on opening day. The Natchaug River runs for less than eighteen miles through the bucolic woodlands of eastern Connecticut. The river is best known for its excellent trout fishing and whitewater rapids.

Right: Yantic Falls, known as Indian Leap, was a favorite encampment of the Mohegan Indians. In 1643 Uncas, Sachem of the Mohegans, led his warriors in the famous battle against their rival tribe the Narragansetts. During the battle, the Narragansetts were pursued by the Mohegans. Legend has it that a band of Narragansetts, unfamiliar with the territory, unknowingly reached the high treacherous escarpment of the Falls. The Narragansetts, rather than surrender, attempted to leap the chasm. Unsuccessful, they plunged to their deaths into the abyss below. This description is from a placard at the park in Norwich, Connecticut.

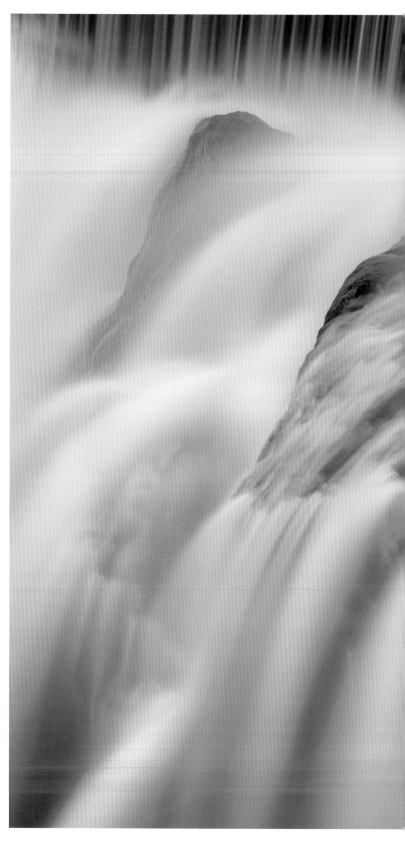

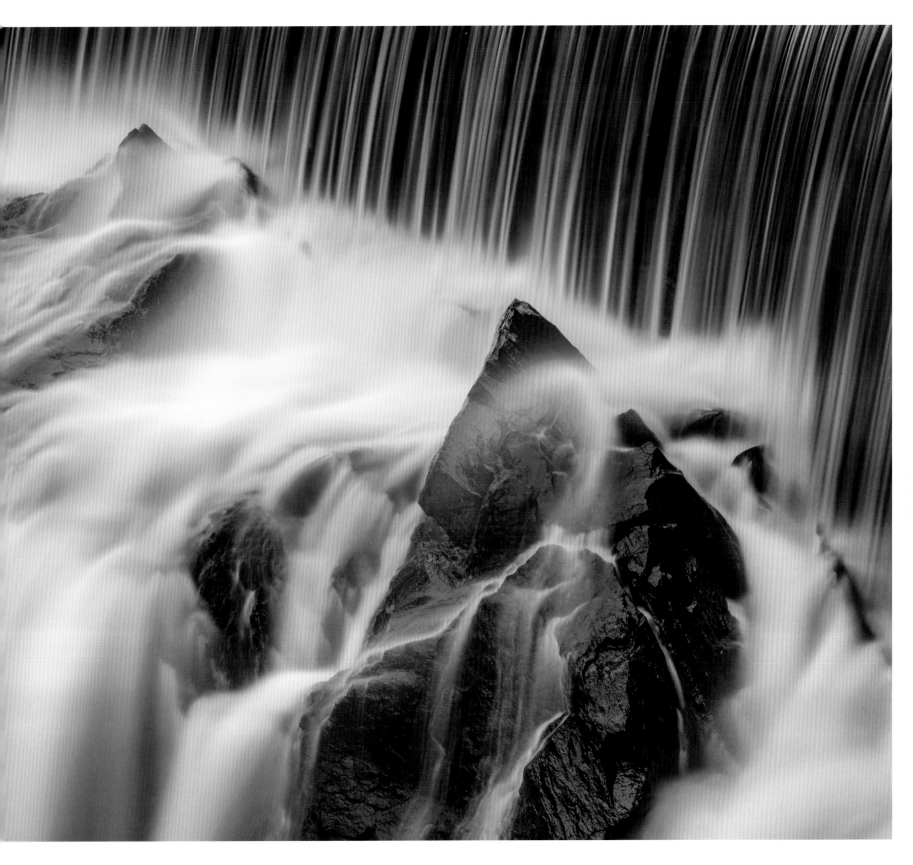

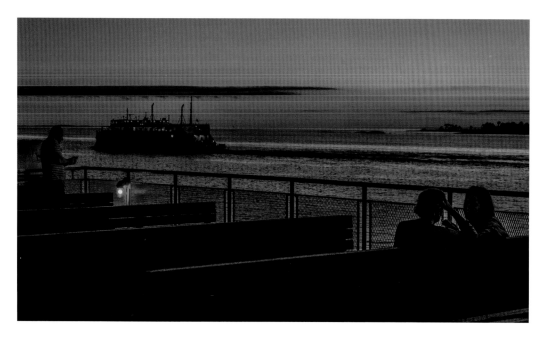

Above: The Cross Sound Ferry operates between New London and Orient, Long Island, New York. The ferry helps passengers avoid as much as 200 miles of tough city driving a day. New London is located on the Thames River on the opposite shore of Groton, Connecticut.

Right: Vistors enjoy the view from Avery Point in Groton, Connecticut. Avery Point is located at the mouth of the Thames River and looks out onto Long Island Sound. Avery Point offers splendid views of the area and is home to the Avery Point Light Lighthouse, which was built in 1943.

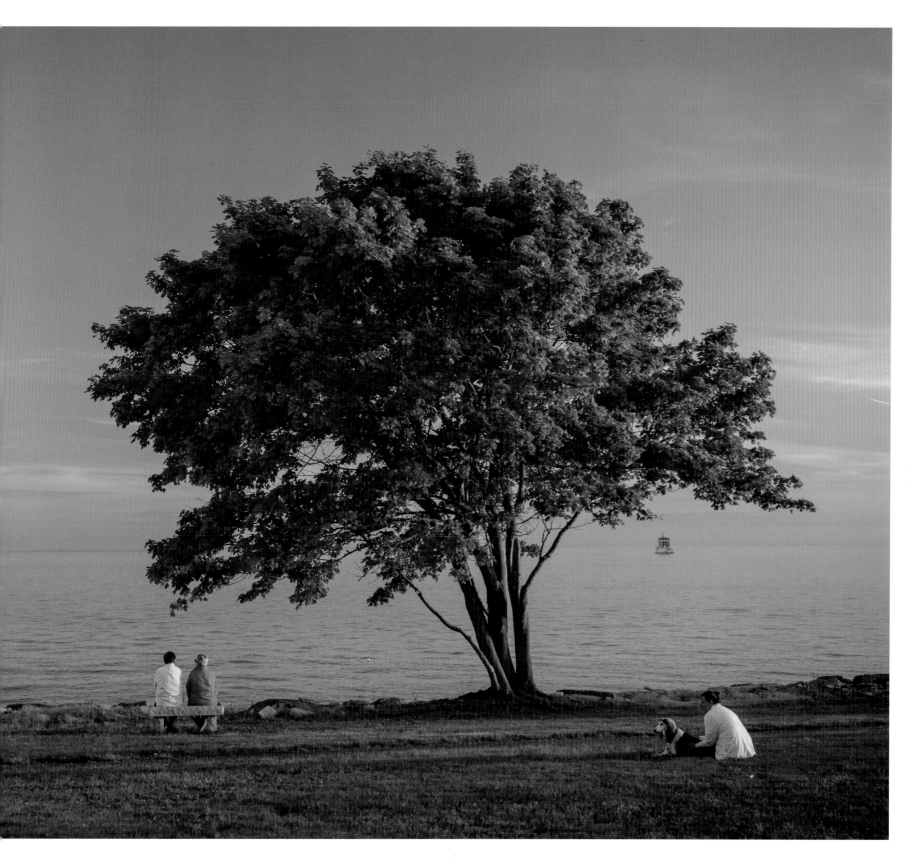

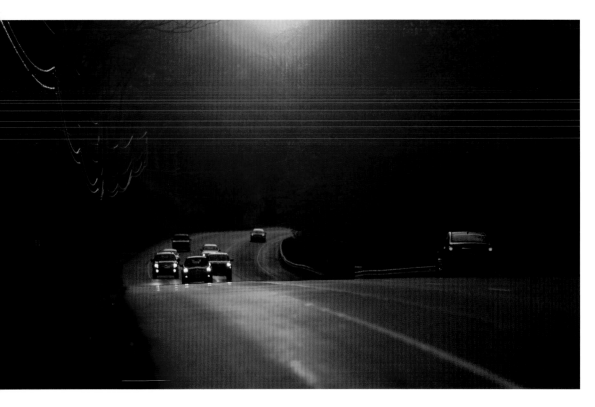

Above: The sun sets along U.S. Route 44 in Connecticut. Route 44 runs for 237 miles from Hudson Valley in New York to Plymouth, Massachusetts. The old turnpike was known as the Old Boston Turnpike; the east-west running road connects the area to Boston and Providence.

Right: The sun sets behind Elijah Pemberton dressed in an inflatable bubble at the Brooklyn Fair in Brooklyn, Connecticut. Brooklyn is located in Windham County and is named after the Quinebaug River. The river helps form the town's eastern boundary, the Brook Line.

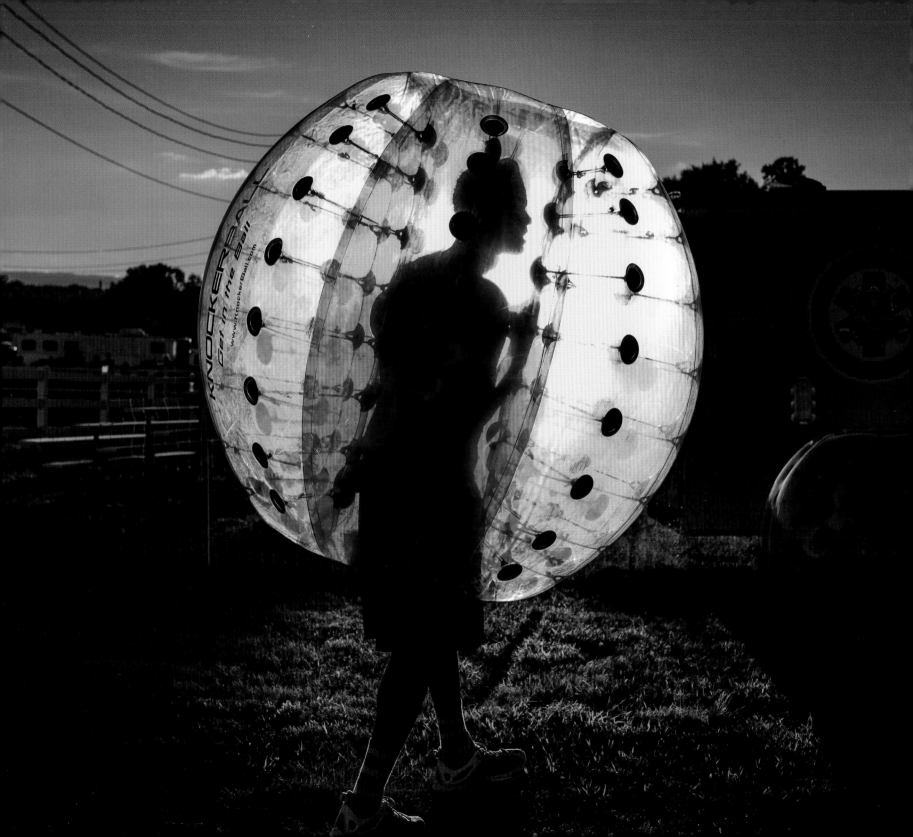

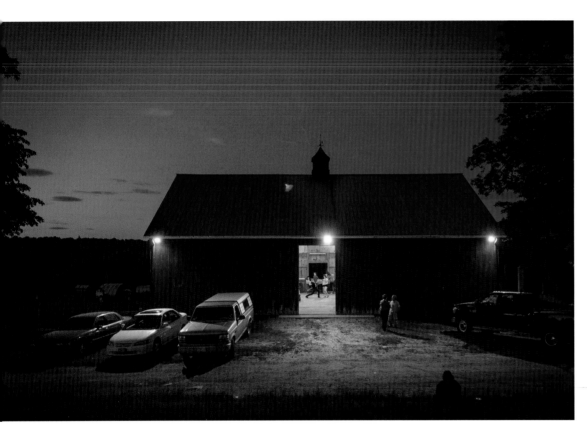

Above: Blue Slope Farm in Franklin, Connecticut, uses agritourism to help the family farm during changing economic times. The farm is home to over 200 cows but also holds a number of events to make ends meet. An Amish group from Pennsylvania built the farm's barn. The barn also houses a number of antique farm implements.

Right: John Newroski plays the fiddle for a square-dance band at the Blue Slope Farm barn dance. The farm is a 380-acre dairy farm that hosts square dances several times each year. Agriculture continues to play a role in Connecticut's economy, The dairy industry is second only to horticulture in agricultural production.

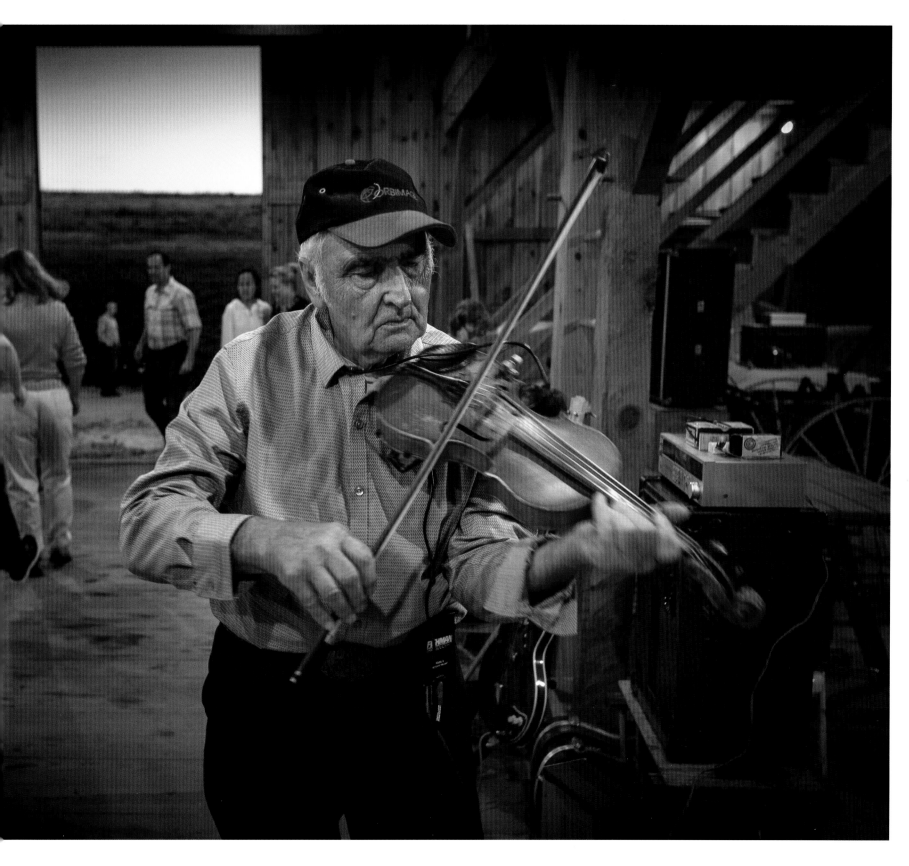

Above: The Mohegan Sun casino sits on the banks of the Thames River in Uncasville, Connecticut. The Mohegan Native American Tribe is one of two tribes recognized by the federal government in the state of Connecticut. The tribe was historically located in the Thames River Valley area.

Right: Over 5,000 one-arm bandit slot machines fill the floor at the Mohegan Sun Casino along the banks of the Thames River in Uncasville, Connecticut. The casino is one of the largest in the country, with over 10,000 employees.

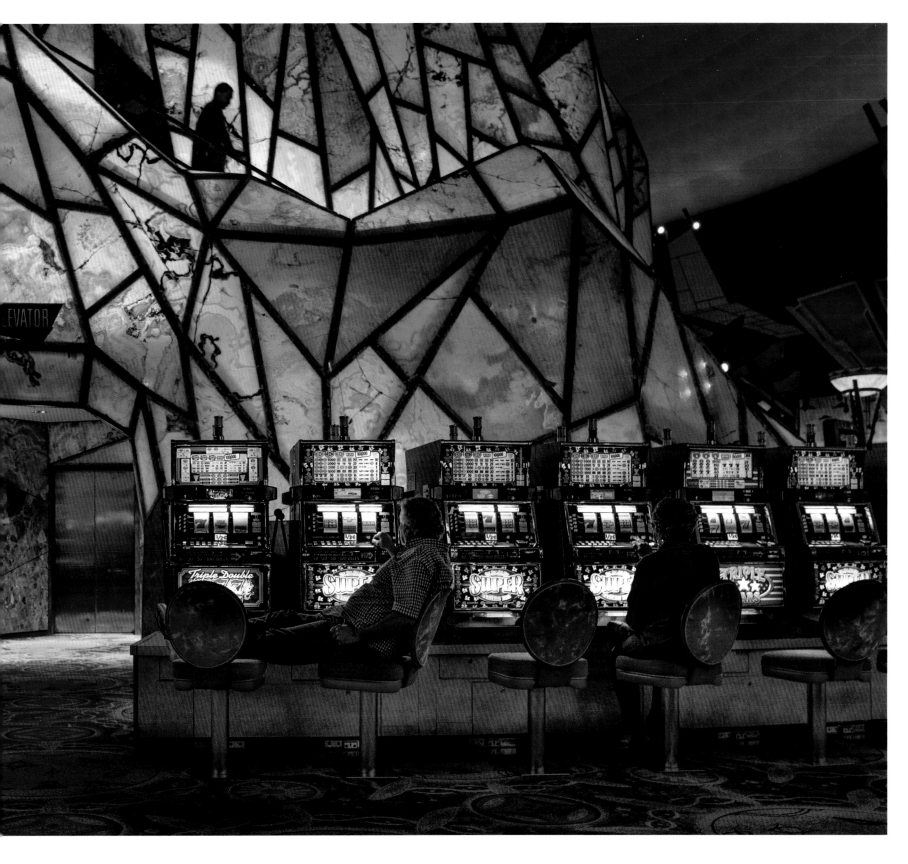

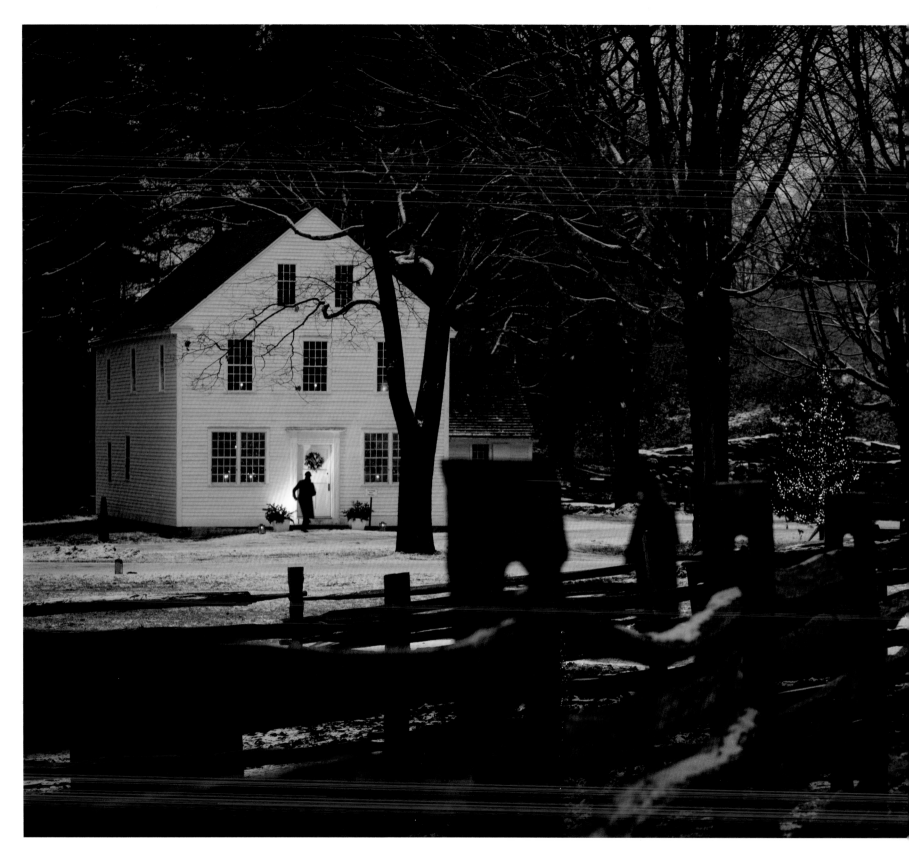

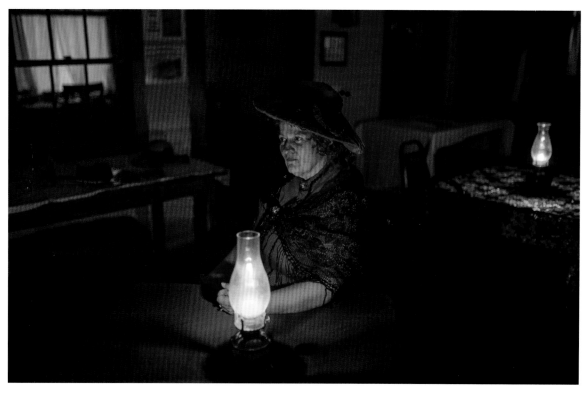

Above: Bev York waits for her tour at the Windham Textile and History Museum in Willimantic, Connecticut. The museum is located at the former headquarters of the American Thread Company.

Left: A light dusting of snow coats the ground in front of the Asa Knight Store in Old Sturbridge Village, Massachusetts. "The store was originally built as a modest one-story building. By 1838, it had grown into an imposing two-and-a-half-story emporium that stocked an expanding variety of products." Old Sturbridge Village, History Museum.

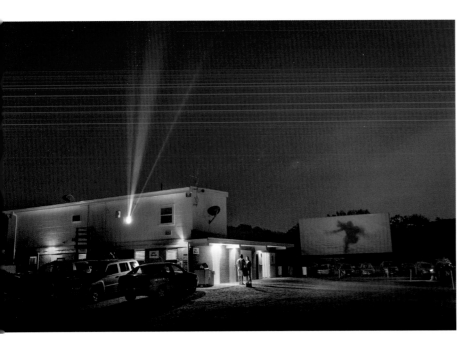

Above: In its heyday, Connecticut boasted over forty drive-in theaters. Today, the state has only three drive-ins. Given the high land values and declining revenues, the businesses suffered one of the highest attrition rates for drive-ins. A full 95% of its drive-ins have gone dark or have been demolished. The largest remaining outdoor theater is the Mansfield Drive-In; it boasts three screens and can park nearly 1,000 cars.

Right: The University of Connecticut students pour onto a plaza at the Storrs campus after watching their team win the NCAA national championship in men's basketball. UConn defeated Kentucky, 60-54. In 2014, UConn won both the men's and women's national championships.

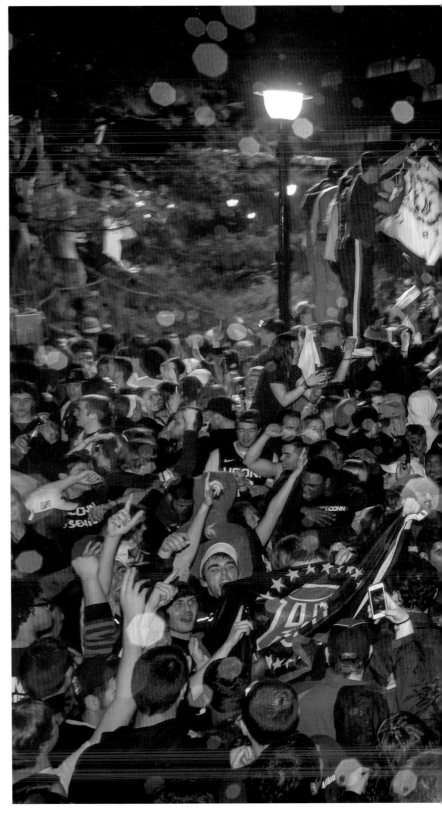

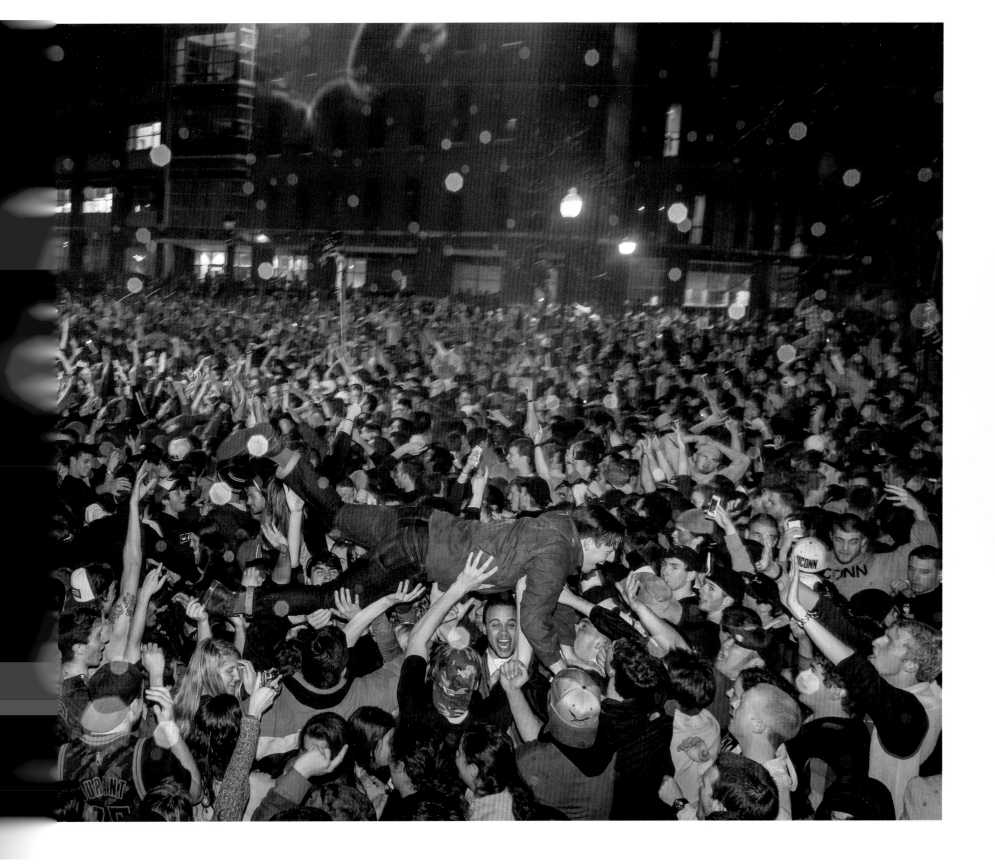

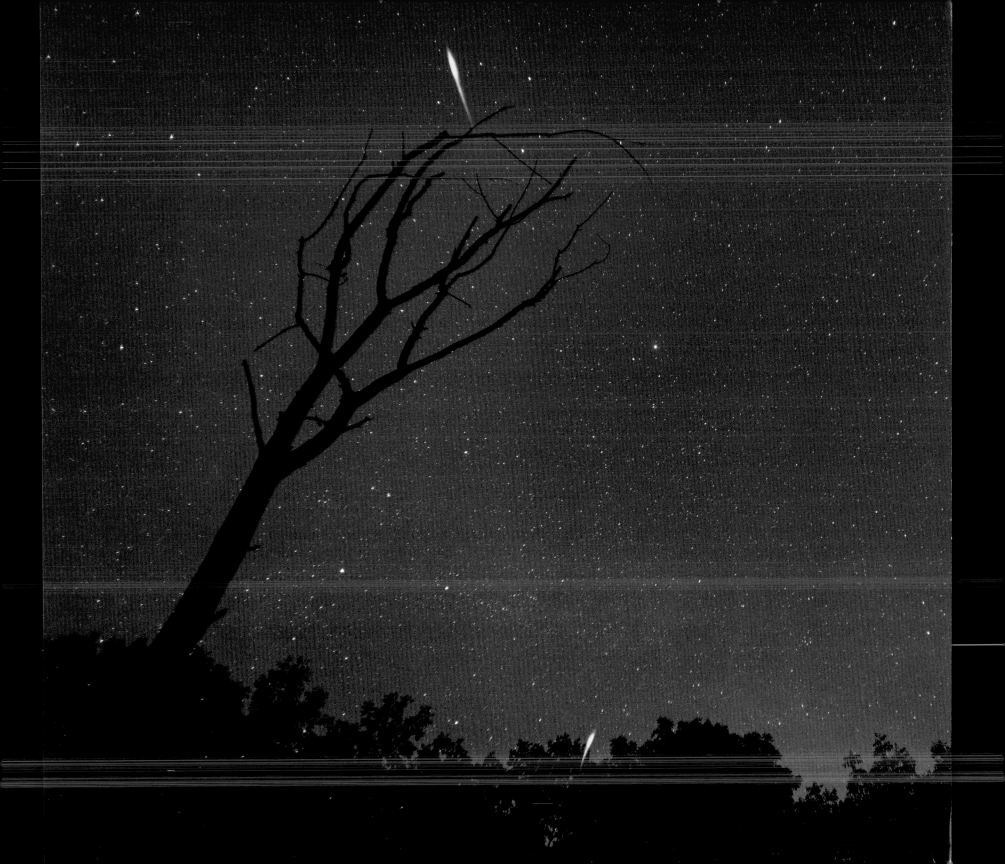

Fireflies race against the starlit sky of northeastern Connecticut. At night, this is one of the few remaining regions that appear "dark" amid the urban and suburban glow of the Northeast seaboard. The Boston to Washington Corridor is the most densely populated region of the United States; it is known as the Northeast megalopolis. According to a recent U.S. Census, the region is home to over 55 million people. The Thames River Basin offers a small reprieve from the densely populated cities.

Eagleville, Connecticut

How I Came to Appreciate the Valley

I first visited the Thames River Valley in the summer of 2013 when I moved to the area from the mountains of Colorado. I work as a visual journalist, and I am an explorer at heart. I probably have my parents to thank for this. My family moved to West Africa when I was in grade school. It may have been this journey that taught me to love and appreciate exploring new places and meeting new people.

In my career as a photojournalist, I was paid to explore – to visually search for new and interesting people and stories. My field has given me the opportunity to travel and learn about this great country. When the opportunity came to move to New England, I was delighted.

I have enjoyed exploring the rivers and valleys of the Thames Watershed. I have learned to love the quiet beauty of the New England landscape. However, it has been the people that have impressed me the most.

Mansfield Center, Connecticut

Thoughts About Photography and Technique

Cameras play such a crucial role in visual storytelling that sometimes it's easy to overlook other aspects of photography. I feel that equally, important artistry lies in our ability to see in unique and interesting ways. Developing observation skills is probably not nearly as exciting as talking about cameras, but proves to be a treasured competency in this form of storytelling. Trying to develop a compelling aesthetic has been one of my deepest challenges.

Equally, a deep visual curiosity is a valuable asset. A curiosity that drives you to explore and wonder "what if?" may be one of the most important attributes in our field. Another often overlooked quality is our ability to perceive a story and our capacity to research for unique and interesting ideas.

With that said, I'm probably your stereotypical photographer, and of course, cameras and lenses are my essential tools. The vast majority of this project was photographed using Canon digital cameras with a wide variety of lenses, including 24mm, 35mm, 100mm macro, 200mm, and 300mm lenses. When I am working in the field, I try to be a minimalist when it comes to bringing cameras and other gear. I prefer to simplify my setup. I find that carrying less gear gives me greater freedom in the field. I hope that this mobility leads to increased endurance and better images. I use a tripod when I am working with long exposures or long lenses.

I am drawn to photography for its unique ability to capture a moment and archive it. I am also intrigued by the idea of searching to find uniqueness within reality. I love images that work on multiple levels, so the story, light, aesthetic, and moment collide.

I want the act of seeing, composing, researching, and understanding to be one of the primary creative acts. I choose to use the camera, lighting, vantage points, composition, and moments as visual expressions. My desire with these images is to show creativity through truthfulness.

Acknowledgments

A special thank you is in order for the following people. Without their help, this project would not have been possible.

Kate Farrish, for her advice and local expertise. It was a pleasure to get to know and work with Steve Grant. His well-written foreword helps bring this story together. Maureen Croteau, for her leadership and gentle guidance during this project. Lois Bruinooge, the executive director of the Last Green Valley, gave graciously of her wisdom. George Thompson played a major role as a mentor and editor on the project. The staff at Wesleyan University Press played a significant role and, without them, this project would not have been possible.

My wife, Gwyn Smith, for her loving support and encouragement. My parents, Daryl and Gladys Smith, who helped nourish a spirit of exploration and wonderment.

Another special thank you goes to the people of eastern Connecticut, who helped make this project possible.

Suggested Readings and Links

Connecticut: *A Guide to its Roads, Lore and People*
Wally Lamb, *I Know This Much Is True*, Fiction
The Last Green Valley, http://thelastgreenvalley.org
The Quiet Corner CT, http://quietcornerct.com
Joshua's Tract Conservation and Historical Trust,
http://joshuastrust.org

Old Furnace State Park, Danielson, Connecticut

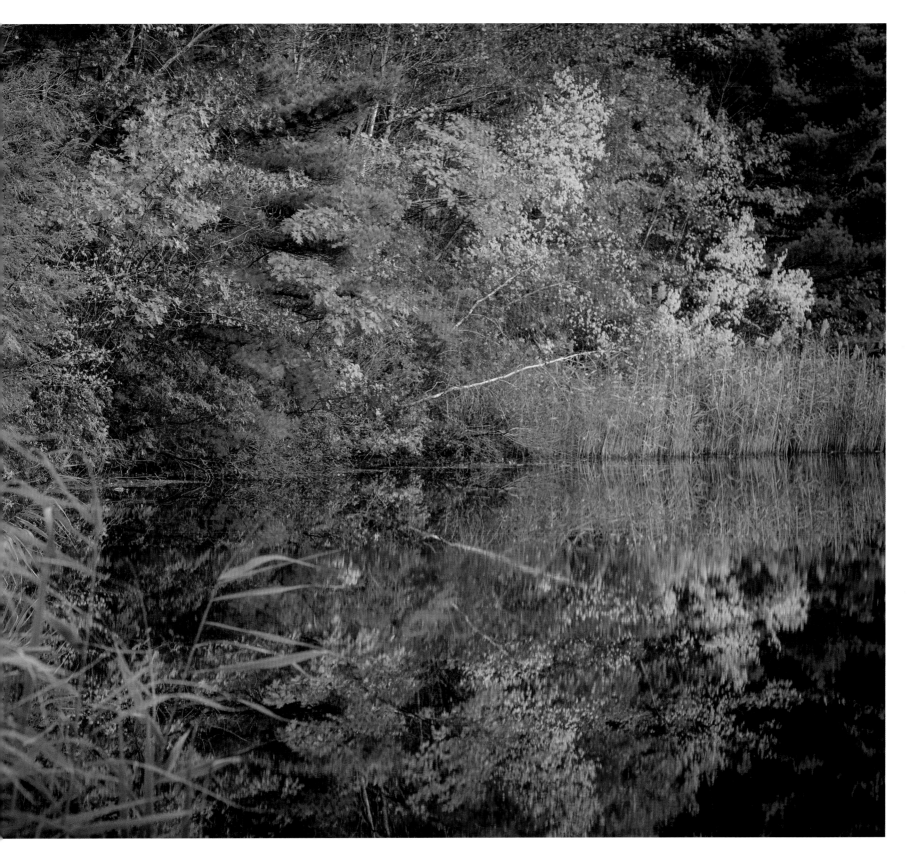

About the Authors

Steve Grant

Steve Grant is a freelance writer living in Farmington, Connecticut. Grant is also a certified yoga teacher and an outdoor recreation guide. In a 29-year career at *The Hartford Courant*, Connecticut's largest newspaper, Grant wrote extensively on nature, outdoor recreation, adventure travel, the green movement, agriculture, energy, and the natural sciences.

Grant has written hundreds of articles on rivers and river issues. He has paddled most of New England's best-known rivers in a canoe or kayak, and once canoed the 410-mile-long Connecticut River from its source on the Canadian border south to Long Island Sound over a five-week period, camping on the riverbank along the way and producing a widely-acclaimed 17-part series of articles for *The Courant*.

During his newspaper career he received more than three dozen awards from various professional organizations for distinguished journalism. In March, 2010, the University of Connecticut's College of Agriculture, Health, and Natural Resources named him the first recipient of its Outstanding Environmental Leadership Award for career-long contributions on behalf of Connecticut's natural resources. In 2014, Grant was the recipient of the Bud Foster Award, given each year by the Connecticut River Watershed Council to an individual who demonstrates "outstanding devotion, service and accomplishment" in efforts to restore and protect the Connecticut River.

As a freelance writer, Grant continues to write about nature, environmental history, and outdoor recreation and is working on a book-length project, a complete guide to adventures in the Connecticut outdoors.

Grant is a member of the Society of Environmental Journalists, the New England Travel Writers Network, the Farmington Land Trust, and the Thoreau Society. He is a founder and former president of the Capitol Bird Club in Connecticut.

He and his wife, Susan, have two adult children, Allison Sterner and Scott Grant, and two grandchildren, Cy and Anderson Sterner.

Steven G. Smith

Steven G. Smith is a Pulitzer Prize-winning multimedia photojournalist and associate professor of visual journalism at the University of Connecticut. His work is built around an aesthetic drawn from his appreciation for people, culture and art.

For more than 25 years, Steven G. Smith's images have graced the pages and the airwaves of the most prominent media organizations, including *The New York Times, Time, USA Today, ABC News, The New York Times Magazine,* National Geographic Channel, *ESPN the Magazine, U.S. News and World Report,* CNN, PBS Public Broadcasting Service, Time.com, *Smithsonian Magazine,* the Associated Press, MSNBC.com, *Life Magazine,* and Corbis Images photo agency.

Smith has also won ten POYi awards over the years from Pictures of the Year International (POYi), including five individual awards such as 1st Place Feature Photography, and 1st Place Magazine Pictorial, as well as prestigious team honors like the Angus McDougal Award for Overall Excellence. Nominated for the Pulitzer Prize four times, Smith won the award in 2002 as part of a small group of photographers who created a substantial documentary essay on the Colorado wildfires for the *Rocky Mountain News.* Smith received a second nomination that year as well – for his visual reportage of the 2002 Salt Lake Olympics.

Smith's images have been exhibited at a variety of prominent institutions in the field, including the Smithsonian, the National Press Club, the Poynter Institute for Media Studies, the International Professional Photography Hall of Fame and the Science Museum. His work was also awarded an American Master Artist Grant by the National Endowment for the Arts (NEA). His work is on permanent exhibit at the Newseum, showcasing one of his Pulitzer Prize-winning images.

Embracing the convergence brought about by the digital revolution, Smith mentors students in the incorporation of cinematic principles into multimedia visual journalism, and his work recently won Best in Show in the S.T.E.A.M. category of the New Media Film Festival in Los Angeles.

Steven has been blessed with an enjoyable career he loves, which has enabled him to work with amazing people. Happily married to his wife Gwyn, together they raised two sons, Luke and Cole. Gwyn and Steven enjoy hiking in the woods with their dogs, Red and Lily.

Garnet Books